D0953453

"If you thought you knew something about relationships, think again. Iris Gottlieb has created a curiosity cabinet full of surprising partnerships in the natural world. I learned something on every page—and laughed at the witty takeaways. Anyone who loves nature will love this charming, illuminating book."

—**JENNIFER ACKERMAN**, author of *The Genius of Birds*

..................................

"An appealing and quirky exploration of who does what to whom in nature. Iris Gottlieb's whimsical art and prose complement one another as neatly as the relationships she describes. Delightful!"

—**THOR HANSON**, author of *The Triumph of Seeds*

..................................

"A beautifully illustrated, humorous, and enlightening reminder that no living being on this earth is (for better or for worse) truly alone. I finished this book with a renewed sense of wonder at the interconnectedness of everything."

—**YUMI SAKUGAWA**, author of *There Is No Right Way to Meditate: And Other Lessons*

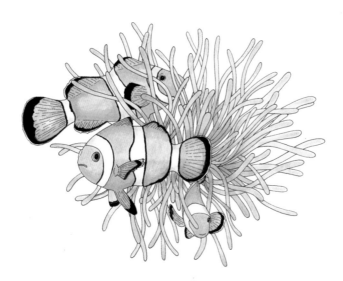

Natural Attraction

Natural Attraction

IRIS GOTTLIEB

A FIELD GUIDE TO
Friends, Frenemies,
and Other Symbiotic
Animal Relationships

SASQUATCH BOOKS
SEATTLE

Copyright © 2017 by Iris Gottlieb

All rights reserved. No portion of this book may be reproduced
or utilized in any form, or by any electronic, mechanical, or other
means, without the prior written permission of the publisher.

Printed in China

Published by Sasquatch Books

21 20 19 18 17 9 8 7 6 5 4 3 2 1

Editor: Hannah Elnan
Production editor: Em Gale
Design: Tony Ong
Copyeditor: Sarah Kolb-Williams

Library of Congress Cataloging-in-Publication Data is available.

ISBN: 978-1-63217-101-6

Sasquatch Books
1904 Third Avenue, Suite 710
Seattle, WA 98101
(206) 467-4300
www.sasquatchbooks.com
custserv@sasquatchbooks.com

For my own symbiotic creature, Bunny the dog

Contents

Introduction XIII

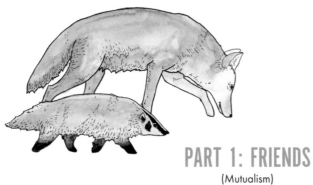

PART 1: FRIENDS
(Mutualism)

PART 2: FRENEMIES

(Commensalism)

......................................

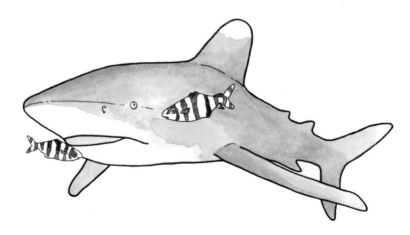

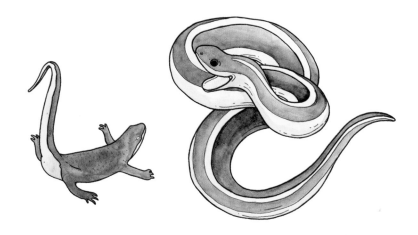

PART 3: ENEMIES

(Parasitism)

..

Introduction

Best buds, frenemies, freeloaders, bullies, copycats, hangers-on, teammates, roommates, landlords, neighbors, homewreckers, collaborators, fakers, manipulators, stone-faced killers. We're accustomed to all types of people and human interactions. But animal relationships can be just as weird and complex.

In fact, they can be a lot weirder: throughout the natural world, birds, mammals, reptiles, plants, insects, fish, algae, fungi, and bacteria form unusual partnerships with other species. There aren't enough relationship-status updates in the universe to cover the ingenious bonds that animals form with each other: tarantula-frog roomies; fish-eel hunting dances; aphid-milking ant farms. The creatures and combinations are sundry and strange.

Sometimes these odd relationships benefit both parties. Flowers attract insects and birds, for instance, which spread pollen and seeds and ensure that the plant reproduces. Insects and birds, in turn, get a lifetime of meals out of the arrangement.

Sometimes the relationships appear to benefit only one species, like birds that build their nests near wasp colonies to ward off predators. And sometimes one creature's very existence depends on it harming the other: beetles that lay their eggs in, and thereby doom, forest pine trees, for instance, or fungi that propagate by transforming insects into zombies.

No matter who comes out ahead, all of these relationships are considered to be symbiotic: species living in close association with each other—for better or for worse.

Symbiotic relationships play a huge role in driving and shaping evolution. Species evolve in response to one another to suit their own survival needs—developing, in some cases, really bizarre traits along the way (such as crustacean fish-tongue impersonation and octopus identity theft). Even in death, symbiosis continues. A dead whale carcass may nourish sea-floor dwellers for up to two hundred years. A fallen redwood provides a nutrient-rich home for generations of plants, fungi, and animals. Symbiotic relationships can, indeed, form the bedrock of entire ecosystems, and if these connections come undone, whole systems can collapse.

No man—or animal, or plant, or fungus—is an island. These strange and astounding natural relationships serve as a reminder, if ever there was one, that all life is intertwined. (Relationship status: it's complicated.)

We need each other. Even when, sometimes, we also eat each other.

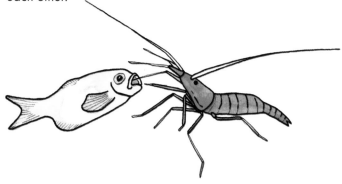

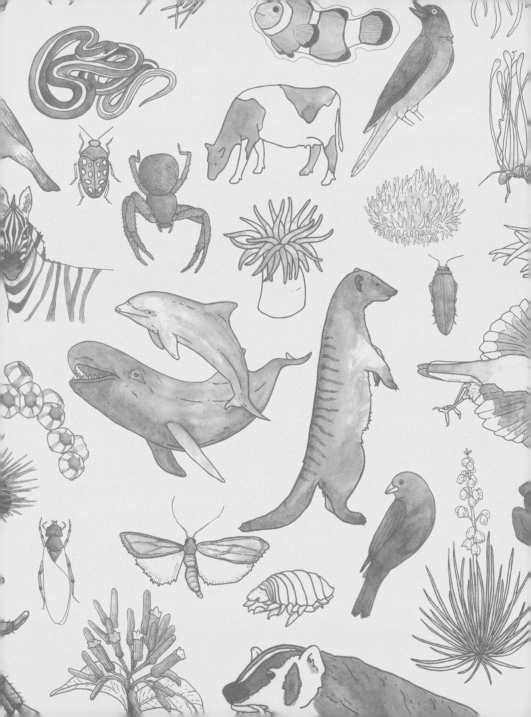

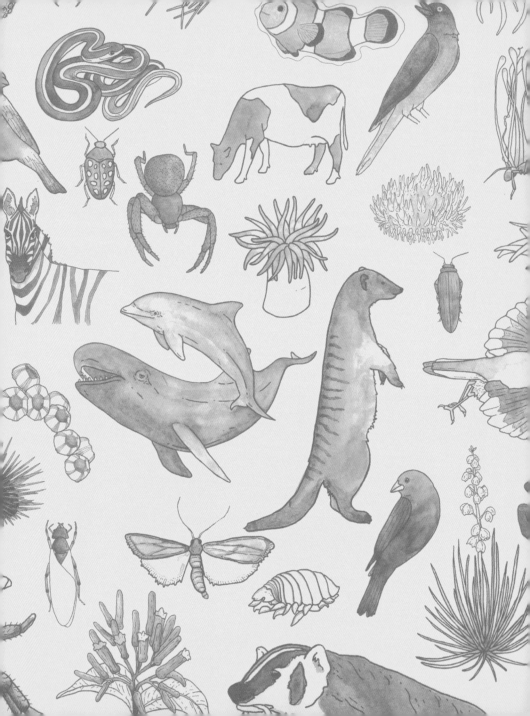

FRIENDS

Mutualism

Mutualism is like the high five of the natural world. It's the sweetest, most cooperative sort of interspecies relationship. You scratch my back (or pull the ticks off of it to keep me safe from disease), and I'll scratch yours (or make sure you're always well fed). Everyone is happy. Everyone wins.

Many of these nurturing relationships are not only vital but invisible to us. Consider, for instance, the microbes that live in our guts, helping us digest our food and, in turn, receiving nutrients and a safe place to live. Or the fungi that find safe harbor in roots beneath the soil, helping their plant landlords absorb nutrients and water.

Nature can be cruel: it is, wrote the poet Alfred, Lord Tennyson, "red in tooth and claw." But these relationships show that it can also be wonderfully kind.

An Oceanic Car Wash

CLEANER SHRIMP AND REALLY CLEAN FISH

WHERE Coral reefs around the world

RELATIONSHIP STATUS Spotless. When dirty fish see the cleaner shrimp, they signal they're ready to be cleaned by opening their mouths and sidling up to the shrimps' cleaning stations, where they float patiently while the shrimp munch. Many of these customers could easily—and happily—eat the shrimp. But then what would perform this crucial service? The cleaning acts as a form of protection against predation. Often, the fish will even let the shrimp clean the inside of their mouths.

The shrimp, meanwhile, get fed without having to go looking for a meal. They just hang out, and everyone wins. Some types of shrimp and eel are so happy with the relationship that they choose to live together, making their homes in the same crevices.

TAKEAWAY Don't eat the shrimp that cleans you.

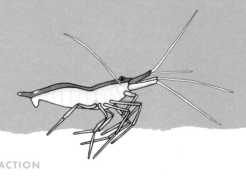

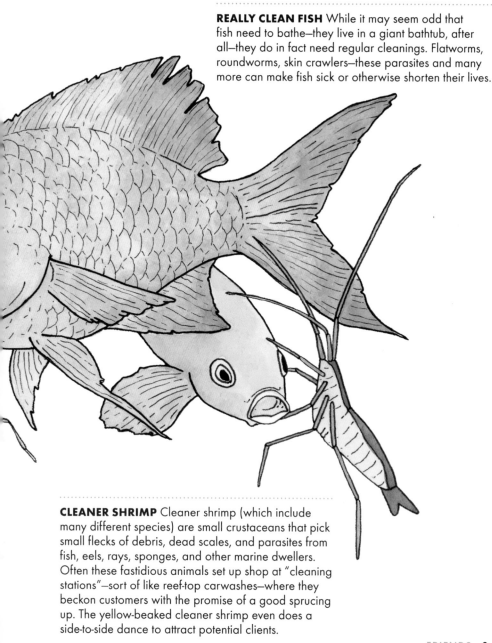

REALLY CLEAN FISH While it may seem odd that fish need to bathe—they live in a giant bathtub, after all—they do in fact need regular cleanings. Flatworms, roundworms, skin crawlers—these parasites and many more can make fish sick or otherwise shorten their lives.

CLEANER SHRIMP Cleaner shrimp (which include many different species) are small crustaceans that pick small flecks of debris, dead scales, and parasites from fish, eels, rays, sponges, and other marine dwellers. Often these fastidious animals set up shop at "cleaning stations"—sort of like reef-top carwashes—where they beckon customers with the promise of a good sprucing up. The yellow-beaked cleaner shrimp even does a side-to-side dance to attract potential clients.

BURROWING TARANTULA This huge, hairy, venomous spider can take down prey twice its size using sharp fangs and a quick ambush. Tarantulas are the largest spiders on earth—some grow as big as ten inches across and can live up to twenty-five years, a terrifying thought. Burrowing tarantulas nest in the ground or in the nooks and hollows of trees during the heat of the day, then emerge to hunt at night, sensing the vibrations and chemical signatures of nearby animals with the sensitive hairs that cover their bodies. For all their lumbering size, they're also stealthy, sneaking quietly, then quickly pouncing on their prey: mostly insects, other spiders, snakes, lizards, and frogs.

DOTTED HUMMING FROG Also known as a microhylid frog, this teeny, narrow-mouthed, rough-skinned, and brown-and-black-pocked nocturnal frog is found in lowland swamps, moist forests, and freshwater marshes.

BURROWING TARANTULA AND DOTTED HUMMING FROG

WHERE Southeastern Peru, Southeast Asia, and south-central United States

RELATIONSHIP STATUS Cohabitation in a spotless den. Tarantulas are fearsome to most amphibians, but when they pounce on dotted humming frogs, they turn into big softies: they somehow recognize the frogs, examining them with their mouthparts and releasing them unscathed. Scientists suspect the frogs' skin contains chemicals that notify the tarantulas that they are a friend, not prey. One scientist tested this hypothesis by covering other species of frog in humming-frog skin and siccing the tarantulas on them. (Here's hoping to never meet that frog-skinning scientist.) He was right: the tarantulas let them go.

The frogs also share the tarantulas' burrows, where the unlikely cohabitants wait out the heat of the day, laying eggs side by side. During nighttime hunts, the frog can sometimes be found hanging out directly under the spider's body, using it, essentially, as a hairy bodyguard that provides shelter, protection, and food: the frogs feed their tadpoles on spider-meal leftovers and gorge on the small insects those leftovers attract.

The tarantula benefits, too, from this arrangement: the frogs like to munch on ants, which feed on tarantula eggs and are too small and agile for tarantulas to catch.

TAKEAWAY Befriend a bully.

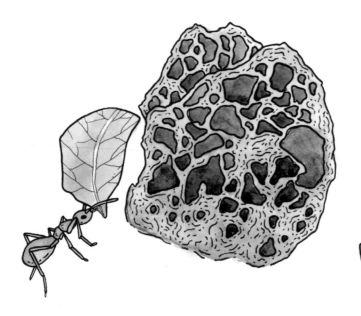

LEPIOTACEAE FUNGUS Leafcutter ants have cultivated a highly specialized type of fungus in the Lepiotaceae family for over fifty million years. Its physical structures have adapted to provide the most nourishment possible for the ant. It grows inflated tips chock-full of nutrients necessary for the ants' survival. Cultivated in a garden bed of plant debris that the ants have transported and chewed up, the fungus feeds on decaying matter, simultaneously feeding the ants and serving an important decomposer role in the forest ecosystem. When the queen ant leaves her colony to begin a new one, she takes a piece of the fungus with her to start her own garden.

Love on the Farm

LEAFCUTTER ANTS AND LEPIOTACEAE FUNGUS

LEAFCUTTER ANT Next to humans, leafcutters form the largest animal societies in the world, housing as many as eight million ants in massive mounds that can span more than two hundred feet in diameter, with subterranean tunnel and chamber systems extending twenty-five feet or more below ground. Leafcutter ants chop up leaves, flowers, stems, and grasses, lugging the plant pieces back to their colonies to turn them into food.

The ants are divided into castes: The queen lays eggs—millions of them. The tiny worker ants, or "minimas," mind the brood and food supply within the underground nest, while the midsize drones forage outside, hauling vegetation that weighs multiple times their body weight along "ant superhighway" paths back to the colony. The monstrous "maximas," or soldiers, defend the colony; their heads are larger than a minima's entire body and their jaws can cut through leather.

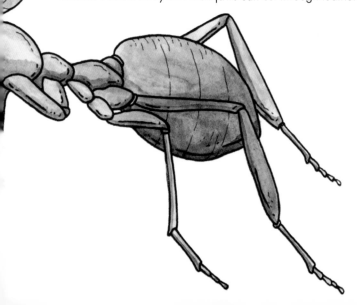

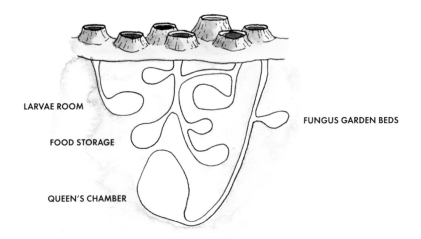

LARVAE ROOM

FOOD STORAGE

QUEEN'S CHAMBER

FUNGUS GARDEN BEDS

WHERE South and Central America, Mexico, and the southern United States

RELATIONSHIP STATUS Well cultivated. Leafcutter larvae feed exclusively on the fungus, which has evolved, over millions of years, to provide essential and specific nutrients for the ants. The fungus gives to the ants; the ants give back. It's an obligate mutualism in which each species needs the other to survive.

Besides feeding the fungus, the ants also keep it healthy. They do so with the help of another symbiotic organism: a type of bacteria that lives in the ant's glands and serves as an antimicrobial agent against molds that could harm the fungus.

TAKEAWAY There's a fungus among us. Literally.

QUEEN

DRONE

SOLDIER

WORKER

An Adorable Friendship

BANDED MONGOOSE AND COMMON WARTHOG

WHERE Grasslands, woods, and savannas of sub-Saharan Africa

RELATIONSHIP STATUS Warts and all. A warthog could easily maim a mongoose, but warthogs are plagued by ticks, and mongooses like nothing better than eating those ticks. Much like the fish that allow tiny shrimp to clean them, the hogs let their small banded buddies climb all over them, feasting on the ticks that the warthogs have no other way to remove. Warthogs will even lie down and roll over onto their sides while an entire mongoose family crawls all over them. Once finished, the mongooses race off and the warthogs quickly stand and go about their day.

TAKEAWAY You scratch my back; I'll just lie here.

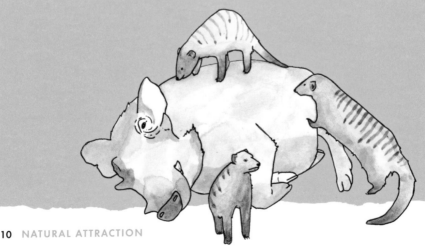

BANDED MONGOOSE Extremely social and excitable, these weasel-like mammals live in groups of up to forty members, sleeping in communal dens in abandoned termite mounds, relocating on a more-or-less weekly basis. Roughly a foot and a half long but weighing only a few pounds, with wiry coats and dark stripes—bands—along their torsos, banded mongooses dine mainly on insects but will also eat bird eggs and small reptiles and mammals. Mongoose moms keep their babies safely underground for several weeks before letting them out to forage and frolic with the pack, and other members of the group pitch in with the childcare.

COMMON WARTHOG As ugly as the mongoose is cute, the common warthog is a crazy-looking wild pig named for the warty-looking chunks of flesh protruding from the sides of the male warthog's face. These weird bulges help protect the animals' faces while they root around in the grass for food. Warthogs can grow to more than three hundred pounds, and while not generally aggressive, they do have tusks that can inflict some damage if necessary. (They also use their tusks for digging.)

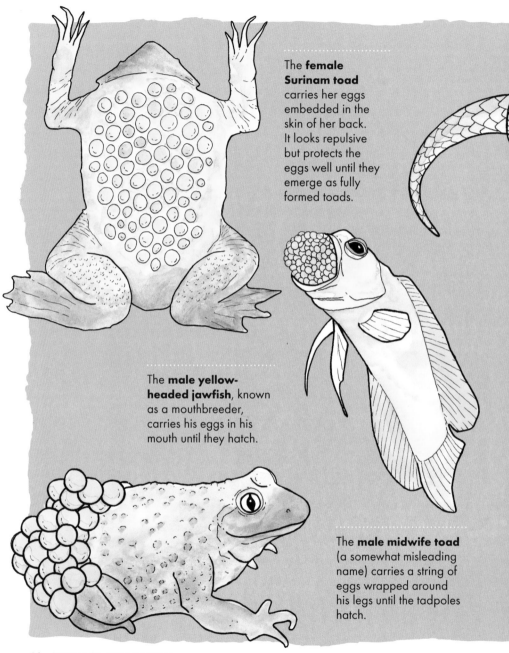

The **female Surinam toad** carries her eggs embedded in the skin of her back. It looks repulsive but protects the eggs well until they emerge as fully formed toads.

The **male yellow-headed jawfish**, known as a mouthbreeder, carries his eggs in his mouth until they hatch.

The **male midwife toad** (a somewhat misleading name) carries a string of eggs wrapped around his legs until the tadpoles hatch.

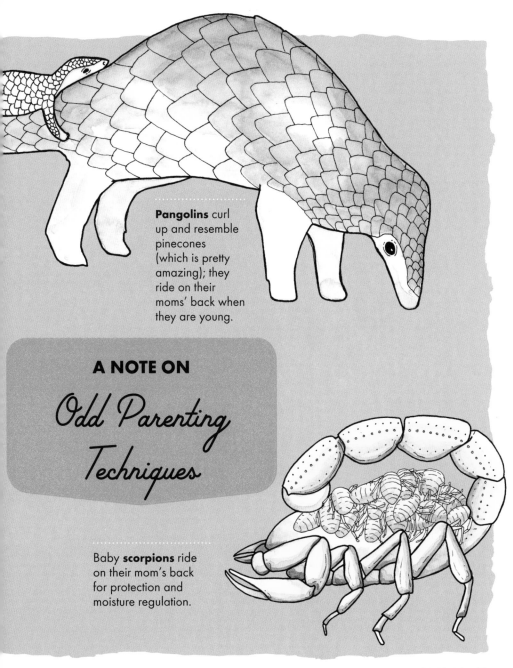

Pangolins curl up and resemble pinecones (which is pretty amazing); they ride on their moms' back when they are young.

A NOTE ON

Odd Parenting Techniques

Baby **scorpions** ride on their mom's back for protection and moisture regulation.

COYOTE This clever dog relative will eat pretty much anything, from grass to fish to rodents to livestock. Shrewd and adaptable, coyotes have spread across North America and as far south as Panama. They live in prairies, forests, and even major cities like Los Angeles and New York. These canids are fast sprinters, are able to run up to forty miles per hour, and have stellar eyesight. At night, coyotes often howl to communicate with each other— a lovely, eerie sound that rises up from the dark.

AMERICAN BADGER This stout little weasel cousin, with a skunk-like stripe on its head and a coat like a raccoon, lives in underground burrows and has a super-keen ability to hear and smell. Badgers are phenomenal diggers, and they rely on their claws—which they keep razor sharp by scratching on trees—to dig for prey such as rodents and rabbits.

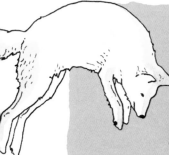

A Predatory Pair

COYOTE AND AMERICAN BADGER

WHERE North American grasslands

RELATIONSHIP STATUS Collaborators. Coyotes and badgers hunt many of the same animals, but they use distinct styles. Badgers dig out rodents from underground; coyotes chase rodents out in the open. So the two team up, hunting in the same area and each catching the animals that come their way. If a mouse, squirrel, or prairie dog stays underground—or if it heads there to escape the coyote—then the badger gets the meal. If the rodent emerges from its hole to escape the badger, the coyote swoops in to snatch it up. While they don't share food, the relationship helps both hunters. Coyotes and badgers will even play together, romping around on the prairie between hunts.

TAKEAWAY The predators that play together stay together.

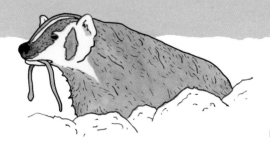

Dining Partners

BLUE WILDEBEEST AND ZEBRA

WHERE Southern and eastern Africa

RELATIONSHIP STATUS They run in the same crowd. Each year, over one million wildebeests and zebras complete a 1,800-mile circular migration through the Serengeti, following the rains in search of food and water. It's a harrowing journey with crocodile-filled river crossings, severe heat, and prowling predators—one better survived in mixed company. Wildebeests have a keen sense of smell, but they can't see very well. Zebras have sharp eyesight and bray loudly when they spot a predator. Together, the two species can warn each other about approaching danger.

Zebras also have strong incisors that let them eat tall grasses, while wildebeests, with their broad mouths, have adapted to eat large quantities of short grass, making the species perfect dining partners. Between the two, they rule the clean plate club.

TAKEAWAY There's safety in numbers.

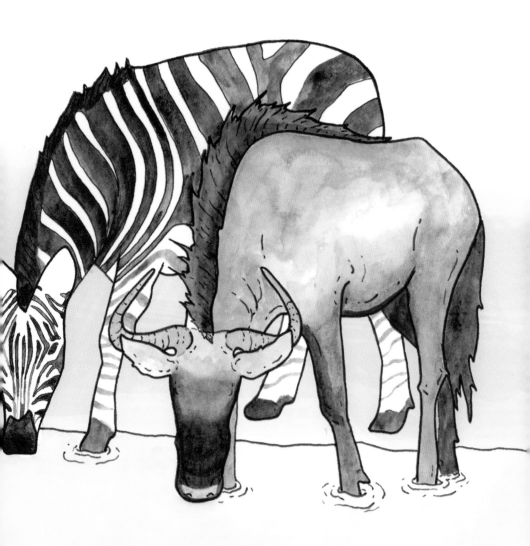

BLUE WILDEBEEST This silver-blue antelope has large horns, a barrel chest, and a boxy face, and it can grow up to eight feet tall and weigh in at six hundred pounds. Blue wildebeests, also known as brindled gnus, travel in large groups for safety and often run at speeds of up to fifty miles per hour, constantly on the move in search of a watering hole. This is where their major predators—lions, leopards, hyenas, cheetahs, crocodiles, and wild dogs—often find them.

ZEBRA An equine cousin of horses and donkeys, the zebra—with its tufty mohawk and black-and-white stripes—is not very subtle against the flat, brown landscape of the grassland. But scientists suspect that those obvious stripes may also serve as camouflage, creating visual illusions that confuse both large predators and disease-carrying flies. Some scientists also theorize that the stripes, which are unique to each zebra, help individuals identify each other in their social groups, known as *harems*.

Zebras are the only equine species that hasn't been domesticated, probably because they freak out when things get stressful, usually running in a zigzag pattern when chased. Not ideal on a racetrack.

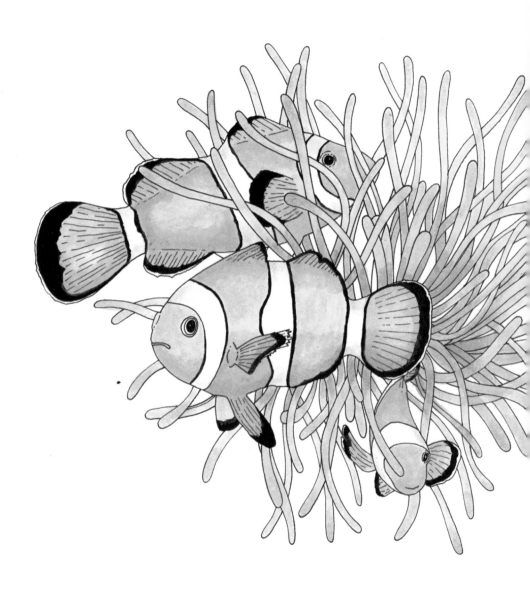

A Very Strange Family Tree

CLOWNFISH AND SEA ANEMONES

WHERE Warm, shallow waters of the Indian and Pacific Oceans

RELATIONSHIP STATUS Landlord and tenant—on good terms. Thanks to the clownfish's mucus coating, it doesn't have to worry about ending up dissolved in an anemone's digestive pit. The mucus lets clownfish survive within the otherwise poisonous tentacles of an anemone, where they're safe from predators that can't survive the anemone's toxin. Anemones provide safe haven.

While there are thousands of types of sea anemones, only a few form a close bond with the clownfish. What do these anemones get out of the bargain? In exchange for giving the clownfish a cushy home in the otherwise inhospitable ocean, the anemones get help finding food: the clownfish help lure in other hungry fish in search of a meal. In addition, the clownfish's motion aerates the water, infusing it with additional oxygen. This lets the anemones live in parts of the ocean that might otherwise be uninhabitable. And the anemones also get to snack on clownfish excrement. Mmm.

TAKEAWAY Keep your friends close and everyone else's enemy closer.

CLOWNFISH These cute, wiggly fish are known for their iconic orange-and-white coloring. They live in family groups made up of one large mating female, one large mating male, and many smaller non-mating males.

The female clownfish lays her eggs when the moon is full. Here's where it gets strange: If the breeding female dies, her male counterpart will quickly change sex and take over her role. Then one of the smaller males will quickly grow big and develop reproductive organs, to become the breeding male. The other fish in the family each move up a rank, but they remain small and non-breeding so as not to upset the hierarchy. This is known as *sequential hermaphroditism*, a common evolutionary development in fish species.

All clownfish, whatever their places in the mating order, wear the same thing on top of their clown outfits: a layer of mucus. It may sound unappealing, but it's the key to the clownfish's survival strategy.

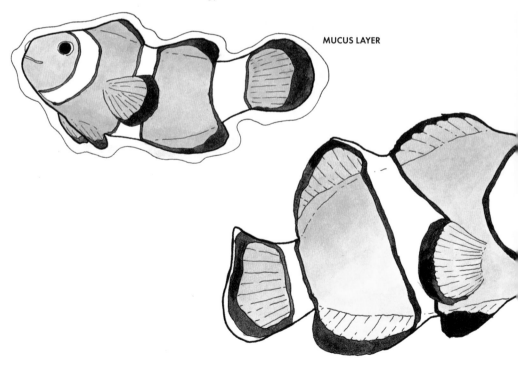

MUCUS LAYER

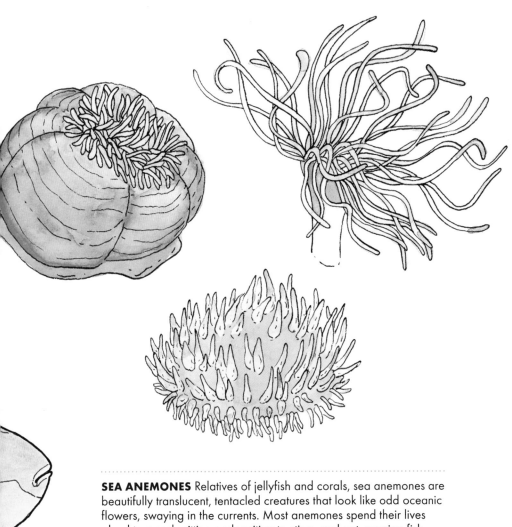

SEA ANEMONES Relatives of jellyfish and corals, sea anemones are beautifully translucent, tentacled creatures that look like odd oceanic flowers, swaying in the currents. Most anemones spend their lives glued to a rock, sitting and waiting to sting—and eat—passing fish. Their tentacles release poison when touched, paralyzing their prey. These tentacles surround a creepy-looking mouth in the center, which leads to a pit of digestive juices, also known as a stomach.

MORAY EELS AND ROVING CORALGROUPERS

WHERE Indo-Pacific coral reefs

RELATIONSHIP STATUS Terrifying teamwork. There are very few fish that hunt cooperatively with other species. But morays and coralgroupers do. Coralgroupers are lethal in open waters; moray eels slink into tight spots to flush out hidden critters. In this case, cooperation is a dangerous weapon.

To alert eels to a target, the groupers find an eel and shimmy their bodies. It's a silent call to action. Then the fish will stand on their heads in the vicinity of the doomed prey to alert the eels in much the same way humans point their fingers. If the moray still isn't interested, coralgroupers will sometimes resort to desperate measures, swimming up to the eel and forcibly trying to push it toward their collective prey. Some eels team up willingly; others prefer to be left alone.

The fish and eel don't share the food; they eat only what they kill. But since they tend to kill more creatures together than apart, it works out well for everyone (except, of course, for the things that get eaten).

TAKEAWAY There's nowhere to hide.

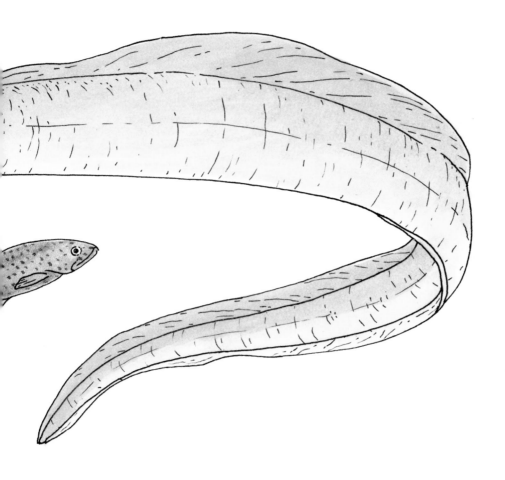

ROVING CORALGROUPER Solitary, spotted, red-orange fish that live near Pacific coral reefs and grow almost four feet long, coralgroupers usually hunt at dusk, darting through the open water and drawing small fish and crustaceans into their large mouths with their powerful suction—then swallowing them whole.

MORAY EEL Long, slinky, gooey, murderously grinning creatures that live in crevices and alcoves in ocean reefs, rocks, and the seafloor, morays can grow up to ten feet long. They have two razor-toothed sets of jaws—one in their mouths and a second set with rear-hooked teeth in the back of their throats, which moves forward and back to grasp and restrain prey (just like those traffic spikes you can only drive over in one direction). Once moray eels latch on, they pretty much never let go, even in death. They must be pried off their victims—small fish, squid, crustaceans, and scuba divers who stick their hands in the wrong hole.

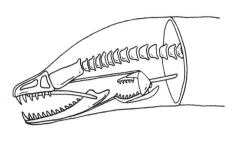

RETRACTABLE
SECOND JAW

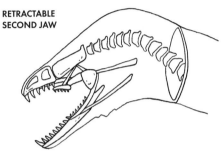

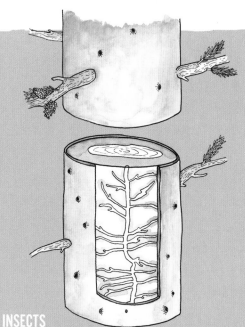

PLANTS

The **strangler fig** is one of the most vindictive plants, encroaching on precious sunlight territory by wrapping its flexible tendrils around trees at an astonishing growth rate. As the vines of the fig grow thicker and taller, the tree beneath is essentially suffocated and eventually dies and disintegrates, leaving a hollow shell made from the hardened exterior strangler fig vines.

INSECTS

The **mountain pine beetle** is a forest's nightmare. Generally preying on older or weaker trees, the beetle burrows under the pines' bark. There, the female lays her eggs, after first severing the tree's resin ducts. When the beetle larvae hatch, they eat the wood. The beetles release a pheromone that beckons others to come join; in response, the tree releases toxic chemicals from its cells, killing the beetles if there are few enough. But with weakened defenses without the protective resin, it often doesn't take many beetles to overwhelm a large tree. The beetles also carry along a blue-staining fungus, which the larvae eat as a sort of vitamin supplement, helping to strengthen the next generation of invaders.

Beings Who Love Too Much

FUNGI

The **honey mushroom** is the largest organism on earth, but it is almost entirely unseen. The fungi grows underground, killing all plant life in its path—the largest recorded single body of the fungus stretches two and a half miles in the Blue Mountains of Oregon. Unlike most parasites that require their host to remain alive to ensure their own survival, the mushroom is a decomposer and thrives on the destruction it creates.

Lichen is not a single organism, but rather a flawlessly symbiotic partnership between algae and fungi. It is massively successful, covering about 60 percent of the earth's land surface in almost every biome including the tundra—it is the staple winter diet of reindeer. Algae provide nutrients via photosynthesis and fungi absorb moisture and nutrients from the surrounding environment, as well as providing a stable structure for the algae to live in. Lichens are the product of the oldest and most prolific farmers, fungi.

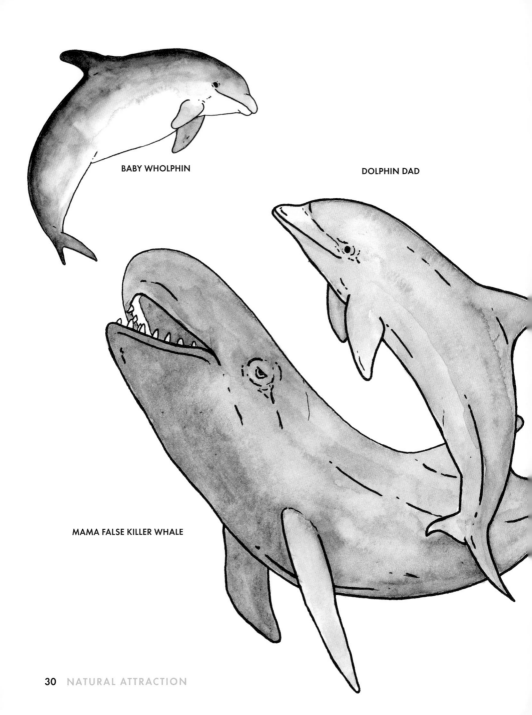

BABY WHOLPHIN

DOLPHIN DAD

MAMA FALSE KILLER WHALE

An Odd Couple

BOTTLENOSE DOLPHINS AND FALSE KILLER WHALES

WHERE Tropical ocean waters

RELATIONSHIP STATUS Hanging tight. Though false killer whales are among only a few cetaceans that consume other marine mammals, they don't eat bottlenose dolphins; instead, they bond with them. On the rare occasions when the falsies have been spotted in the wild, they were often found in the company of bottlenose dolphins.

They likely congregate for pragmatic reasons: the fish they prey on often swim together, and these dolphin cousins may help each other detect predators. But their connection extends beyond simple practicality. When a 2013 study tracked the movements and interactions of the dolphins and falsies over seventeen years, scientists came to realize that the two species were pairing off in relationships that persisted over multiple years and many nautical miles. Scientists saw some of the animals touch as they swam side by side. In fact, the two species have even been known to mate: the hybrid love child is called a *wholphin*.

TAKEAWAY Long-distance (and cross-species) relationships can actually work.

BOTTLENOSE DOLPHINS Widely loved for their cuteness, intelligence, and friendly demeanor, dolphins rank second only to humans in brain-to-body-mass ratio and are incredibly clever. They echolocate, emitting clicking sounds that bounce off nearby objects so the dolphins can determine the objects' distance, size, even thickness (down to the single millimeter). Dolphins also use tools, harvesting sponges to protect their beaks from rocks, corals, and other seafloor hazards. They mate for pleasure and hunt in well-organized groups to corral their prey. They are extroverts, spending much of their free time playing with other dolphins—and with humans, whales, kelp, trash, and even their own air bubbles.

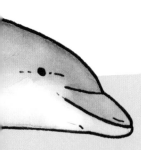

FALSE KILLER WHALES We know remarkably little about the false killer whale—*Pseudorca*—a species of ocean dolphin that looks like a slimmer, black-and-gray version of a killer whale (hence the name). Elusive, introverted creatures that grow up to twenty feet long and weigh up to five thousand pounds—about twice the length and more than ten times the weight of their bottlenose buddies—they dwell in all but the coldest seas across the globe, but humans rarely see them. In fact, they were thought to be extinct until a Danish zoologist named Johannes Reinhardt found a large pod of them in the Baltic Sea in 1861.

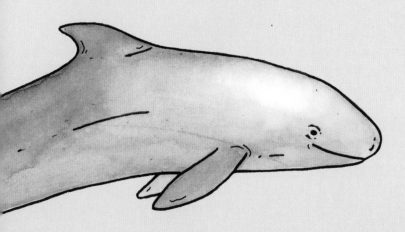

Highly Evolved

YUCCA MOTH AND YUCCA PLANT

WHERE Hot, dry regions of North, Central, and South America and the Caribbean

RELATIONSHIP STATUS They'd die without each other and have coevolved over millions of years. Each yucca species depends on its own highly specialized moth, and if one species perishes, the other does too. When a yucca blooms—generally once a year—male and female moths mate in the flowers. Then the female scrapes a lump of the flower's pollen, tucks it under her tentacled chin, flies off to a fresh flower on a new plant, lays her eggs there, and deposits the pollen on the flower's stigma. And then she dies.

But her young survive her. The caterpillars time their emergence to coincide with the fruiting of the fertilized flower, feeding exclusively on its seeds (while making sure they leave enough behind to perpetuate the species). When the caterpillars are fully grown, they drop to the ground, bury themselves, spin a cocoon, and remain underground until the next blooming season—when they emerge as adult moths, fly up to the plant's flowers, and do it all over again.

TAKEAWAY Coevolution makes for codependence.

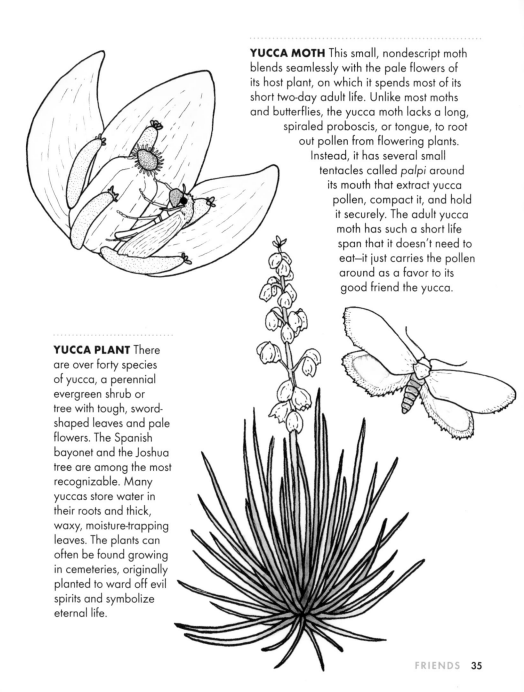

YUCCA MOTH This small, nondescript moth blends seamlessly with the pale flowers of its host plant, on which it spends most of its short two-day adult life. Unlike most moths and butterflies, the yucca moth lacks a long, spiraled proboscis, or tongue, to root out pollen from flowering plants. Instead, it has several small tentacles called *palpi* around its mouth that extract yucca pollen, compact it, and hold it securely. The adult yucca moth has such a short life span that it doesn't need to eat—it just carries the pollen around as a favor to its good friend the yucca.

YUCCA PLANT There are over forty species of yucca, a perennial evergreen shrub or tree with tough, sword-shaped leaves and pale flowers. The Spanish bayonet and the Joshua tree are among the most recognizable. Many yuccas store water in their roots and thick, waxy, moisture-trapping leaves. The plants can often be found growing in cemeteries, originally planted to ward off evil spirits and symbolize eternal life.

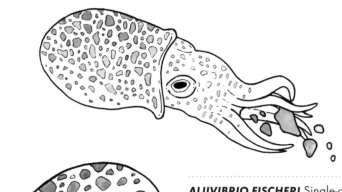

ALIIVIBRIO FISCHERI Single-celled bioluminescent marine bacteria have remarkably sophisticated ways of talking to each other. By using chemical communication, the bacteria are able to signal their location to one another and gather together. Once many bacteria are in the same place (they're unable to glow alone), a biological switch flips on that allows them to glow at once, illuminating the surrounding water (or the creature they're inhabiting).

HAWAIIAN BOBTAIL SQUID These tiny squid, no bigger than a human thumb, live in shallow coastal waters and spend their days buried in the sand. At night, they come out to hunt. But they face a challenge: moonlight casts their shadows on the seafloor, leaving them vulnerable to predators with a taste for squid.

So these crafty cephalopods have evolved an incredible method of camouflage: a "light organ" that lets them glow in the dark. Since they're glowing just like the moon, they have no shadow.

HAWAIIAN BOBTAIL SQUID AND *ALIIVIBRIO FISCHERI* (BIOLUMINESCENT BACTERIA)

WHERE Pacific and Indian Oceans

RELATIONSHIP STATUS Brilliant. Within hours of hatching, the squid take in colonies of luminescent bacteria from the sea around them. Inside the squid's light organ—which lies on its underside—the bacteria multiply until there are enough to make the squid glow. They even have what amounts to a dimmer switch, to make themselves more or less lustrous to match the ambient light. Inside the squid, the bacteria are safe, well fed, and as happy as microbes can probably be.

Each morning at dawn, the squid expels all but about 10 percent of the bacteria back into the sea. Then the animal goes to sleep in the sand, while the bacteria living inside it multiply. By evening, there's a new army of incandescent microbes waiting to turn on the lights and keep the squid from casting a lethal shadow.

TAKEAWAY Darkness cannot drive out darkness; only bioluminescent bacteria can do that.

The Hoarder and the Seeds

CLARK'S NUTCRACKER AND WHITEBARK PINE TREES

WHERE High-altitude conifer forests in the western United States and southwestern Canada

RELATIONSHIP STATUS Tragically interdependent. Clark's nutcrackers go crazy for whitebark pine nuts. They tear into pinecones and pull out the high-protein seeds, storing up to 150 at a time in special pouches in their mouths. Later, they hide the seeds. Each bird gathers and stockpiles up to 90,000 for winter—many more than they can possibly eat. It is still unknown how the birds keep a mental map of where they hide the seeds, but they have an uncanny ability to find them after months and months of snowfall. The extra ones remain underground and grow into new trees.

It's a relationship that's evolved over the ages: the shapes of pinecones and pine nuts have changed over time, transforming to match the birds' particular beak structure. Indeed, bird and tree are perhaps too perfectly adapted: because the bird feeds primarily on whitebark pine nuts, no one knows what will happen to the nutcracker when its endangered major food source vanishes.

TAKEAWAY Hoarders are helpers.

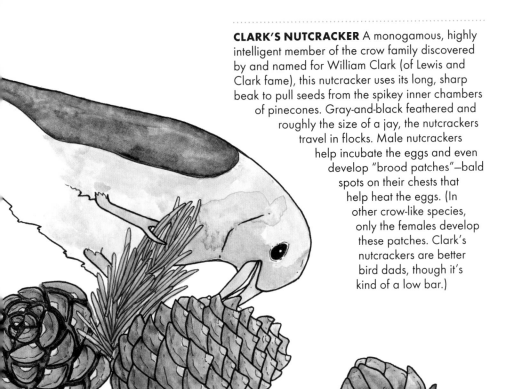

CLARK'S NUTCRACKER A monogamous, highly intelligent member of the crow family discovered by and named for William Clark (of Lewis and Clark fame), this nutcracker uses its long, sharp beak to pull seeds from the spikey inner chambers of pinecones. Gray-and-black feathered and roughly the size of a jay, the nutcrackers travel in flocks. Male nutcrackers help incubate the eggs and even develop "brood patches"—bald spots on their chests that help heat the eggs. (In other crow-like species, only the females develop these patches. Clark's nutcrackers are better bird dads, though it's kind of a low bar.)

WHITEBARK PINE TREES This mountain-dwelling tree belongs to the stone pine group, meaning its seeds are spread by animals rather than by wind or fire. Squirrels and birds distribute the seeds throughout the forest so new pines can sprout. Whitebark pine is a VIP in its mountain neighborhood, helping ensure (with its year-round shade and entrenched root system) that snow melts at a steady pace, which in turn prevents both floods and droughts. Unfortunately, our warming climate is shrinking the whitebark's home ranges and bringing danger—insects, disease, fire—to its door. It's only a matter of time before these trees disappear forever.

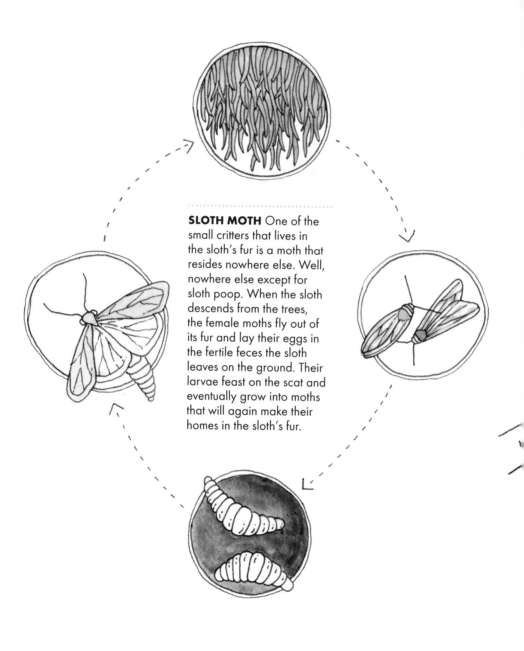

SLOTH MOTH One of the small critters that lives in the sloth's fur is a moth that resides nowhere else. Well, nowhere else except for sloth poop. When the sloth descends from the trees, the female moths fly out of its fur and lay their eggs in the fertile feces the sloth leaves on the ground. Their larvae feast on the scat and eventually grow into moths that will again make their homes in the sloth's fur.

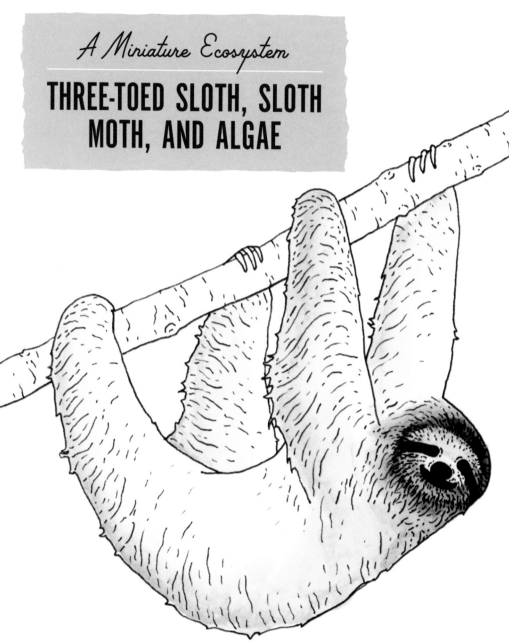

THREE-TOED SLOTH, SLOTH MOTH, AND ALGAE

THREE-TOED SLOTH It's a bizarre animal, really. This smiley-faced mammal with long claws lives in a tree. With a thick, furry, brownish coat teeming with insects, fungi, algae, and other small critters, the sloth is largely motionless for up to twenty hours out of twenty-four. Traveling at a speed that appears to others like slow motion, the sloth moves only forty yards in a day.

Once a week, the sloth heads off on a dangerous mission beyond the safety of high branches. Using its long, curved claws—which it otherwise employs to hang from branches and grab the leaves that form much of its diet—it descends, veeeerrrrry slowly, to the ground. There, it digs a little hole with its tail . . . and defecates. Then, as quickly as it can (which is veeeerrrrry slowly), it climbs back to safety in the canopy.

ALGAE Sloth fur is brown when clean, but it often becomes indistinguishable from the surrounding foliage due to the dense coating of green algae covering the animal's back. Sloth hair has evolved to trap water from rain and moisture in the air, creating a hydroponic garden of sorts where algae can thrive.

WHERE Rainforests of Central and South America

RELATIONSHIP STATUS Slow and steady . . . and smelly. It's pretty clear what the moth gets from the sloth: a gross (but protected) nursery and food source. While the moth larvae feed on the sloth's excrement, the adult moths find their sustenance in the sloth's teeming coat, where the moths have more than enough to eat. They are especially fond of the algae that grows here, and in turn, the decomposing bodies of dead moths fertilize the algae. Sloths that have more moths tend to have more robust algae coats.

When on the ground for their bathroom breaks, the sloth is incredibly vulnerable, with no way to defend itself or quickly escape from a predator. Since more than half of sloth deaths occur then, the decision to come down from the tree is a confusing one on the sloth's part. The motivation behind the sloth's descent is still mysterious—possibly to mark territory, fertilize their tree home, or to continue the life cycle of their moths.

Regardless of why they descend, the descent is beneficial. Scientists believe that the algae the moths live in must act like a sloth nutritional supplement, adding vital fats to the animal's otherwise pretty anemic diet. By keeping the moths in such close proximity, the sloth's access to additional beneficial nutrients increases.

TAKEAWAY I'll risk my life for you. (Why? No one quite knows.)

Following the Light

GOLDEN JELLYFISH AND ZOOXANTHELLAE ALGAE

WHERE Eil Malk, Palau, Micronesia

RELATIONSHIP STATUS Luminous. When golden jellyfish found themselves isolated from the ocean and its nutrients as sea levels receded, they evolved the ability to photosynthesize by absorbing zooxanthellae within their tissues. Because of this the jellyfish follow the sun all day, flipping around gently in the water to sun their backsides. The constant exposure to sunlight makes it easier for the algae to convert light into the energy that keeps the jellies going. That's also why golden jellyfish don't sting: while most jellies gather food by capturing sea-drifting plankton or other creatures in their poisonous appendages, goldens have instead come to rely solely on sunlight for food— something very few animals do—and they lost their long tentacles in the process.

TAKEAWAY Love the one you're with, because you don't really have a choice.

GOLDEN JELLYFISH Bright yellow, teacup-sized, and stingless, golden jellies live exclusively in a saltwater lake known—fittingly—as Jellyfish Lake, where twenty million of them spend much of their lives following the sun's arc across the sky. The jellies cluster on the lake's western shore at dawn, and as the sun peeks over the horizon, they propel themselves eastward, pumping water through their bells. By midday they reach the opposite shoreline, where they stop just short of the tree shadows at water's edge to avoid the shade-dwelling anemones that are their primary predators. The jellies then travel back to the western end of the lake.

Because the basin is connected to the sea only by deep fissures in the glacially formed limestone below, the lake's stagnant bottom is completely devoid of oxygen. But the jellyfish churn and aerate the upper water, distributing much-needed nutrients and oxygen. All told, the jellies swim about a kilometer each day—pretty impressive for a squishy blob.

EVOLUTION OF THE GOLDEN JELLYFISH

Distant past *Past* *Present*

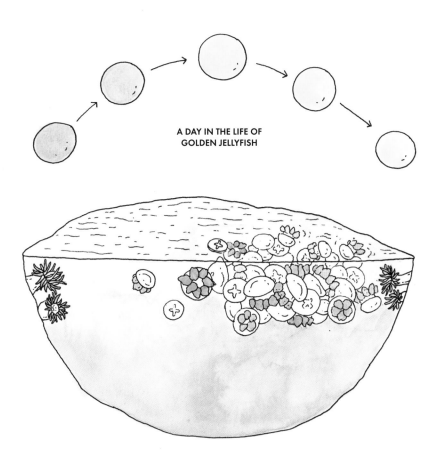

A DAY IN THE LIFE OF GOLDEN JELLYFISH

ZOOXANTHELLAE ALGAE Single-celled, microscopic yellow-and-brown plankton that depend on light to reproduce, anthellae live symbiotically within a number of marine invertebrates, providing up to 90 percent of their hosts' energy through photosynthesis—and turning the creatures yellow or brown in the process. The hosts, in return, protect the algae and provide nutrients, carbon dioxide, and access to sunlight.

Tunneled Together

PISTOL SHRIMP AND GOBY FISH

WHERE The Indo-Pacific

RELATIONSHIP STATUS Mutual care. Despite their menacing superhero claws, the nearly blind pistol shrimp are vulnerable to attack every time they leave the safety of their caves. The gobies become their bodyguards. They stand sentry at the tunnel entry, keeping vigilant watch. Meanwhile, inside, the shrimp play housekeeper and contractor—building, rebuilding, and repairing the burrow, digging with their claws or their back legs.

When outside the burrow, the shrimp stays in constant contact with the goby by keeping an antenna on the fish's tail fin, which flickers with changing intensity based on the level of danger. If the goby darts back into the tunnel, the shrimp knows it must quickly follow its chaperone.

Gobies can also dig burrows, but their structures are lean-tos compared to the shrimps' architectural masterpieces. In exchange for being the shrimps' eyes, the gobies get a solid roof over their heads. Shrimp and goby—sometimes one of each, sometimes several—live happily together in the tunnel. The goby even mates there. When night falls, the shrimp seals off the tunnel and they all sleep safely inside.

TAKEAWAY A seeing-eye goby is a shrimp's best friend.

GOBY FISH These tiny striped or brightly colored fish, some less than an inch long, like to nestle in sandy ocean caves. Goby fish build mounds at the cave entrances so water will flow past and aerate their eggs.

SONIC BOOM

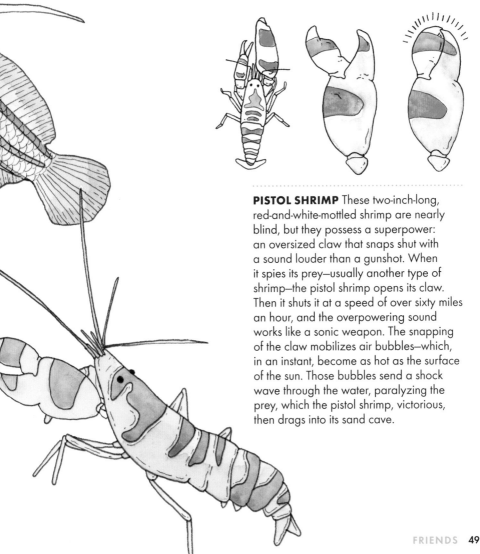

PISTOL SHRIMP These two-inch-long, red-and-white-mottled shrimp are nearly blind, but they possess a superpower: an oversized claw that snaps shut with a sound louder than a gunshot. When it spies its prey—usually another type of shrimp—the pistol shrimp opens its claw. Then it shuts it at a speed of over sixty miles an hour, and the overpowering sound works like a sonic weapon. The snapping of the claw mobilizes air bubbles—which, in an instant, become as hot as the surface of the sun. Those bubbles send a shock wave through the water, paralyzing the prey, which the pistol shrimp, victorious, then drags into its sand cave.

Part 2

FRENEMIES

Commensalism

While not as sweet as mutualism, commensalism is still a pretty decent sort of connection. Nobody gets hurt, anyway, in the bargain. The word *commensal* means *sharing a meal or table*. In practice, it's rarely an even quid pro quo: it's something closer to "Here, you can eat my leftovers from this carcass. I've had enough."

The benefit—which often accrues to the smaller of the two species—can also come in the form of shelter, protection, or a free ride. The big guy can take care of himself; he doesn't mind helping a little guy out from time to time.

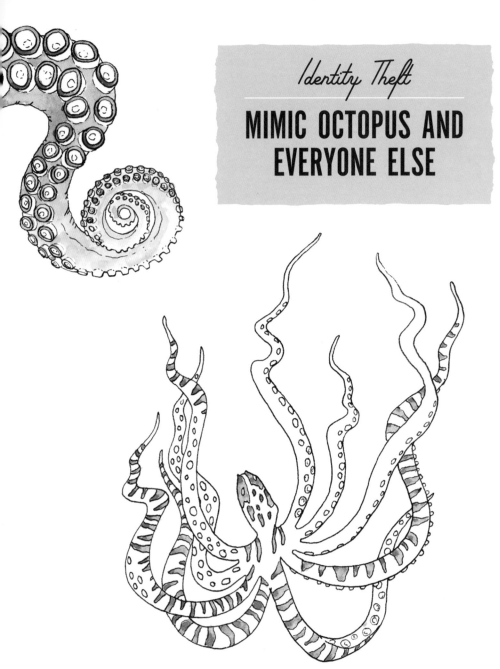

MIMIC OCTOPUS AND EVERYONE ELSE

WHERE Southeast Asia and the South Pacific
RELATIONSHIP STATUS Shifty. Many creatures use mimicry as a survival strategy, but the mimic octopus is the only one known to impersonate such a wide variety of species. Because the octopus has no spines, bones, poison, or tough skin to keep it safe, it instead relies on shape-shifting to imitate the sort of poisonous sea creature that predators generally avoid. To look like a lionfish, for instance, the octopus adopts brown-and-white stripes and shapes its eight legs to look like spines. To resemble a sea snake, it hides in a hole and pokes out two black-and-white-banded legs. To approximate a flatfish, it pulls its arms together and flattens its body. To impersonate a jellyfish, it puffs up its head and lets its arms trail behind. And it's not only adaptable, it's also smart: it recognizes approaching predator species and shape-shifts to resemble creatures they are likely to avoid.

It's not all about self-defense, however. The octopus can also mimic its prey. It will shift shape and color to look like a crab, for instance, in order to lure crabs looking for mates. Then it will devour them (a pretty lousy first date). Mimic octopuses also sometimes eat each other (also a pretty bad date).

TAKEAWAY Don't get suckered: when contemplating a potential suitor, make sure it is not actually a hungry octopus.

MIMIC OCTOPUS Scientists first encountered the mimic octopus in 1998 off the coast of Indonesia, where it hangs out in the muddy waters of estuaries and river mouths, gliding over the sand and feeding on fish and crustaceans. It is quite small—two feet long, with arms the diameter of a pencil. Like all octopuses, it has eight legs, three hearts (even though it acts quite heartless), and a siphon for jet propulsion. Unlike many other octopuses, the mimic—which is light brown or beige at rest—can change color and pattern at the drop of a hat, using specialized pigment sacs known as *chromatophores*. It can morph its body shape as well. It is, indeed, the most sophisticated copycat on land or sea: highly intelligent, incredibly adaptable.

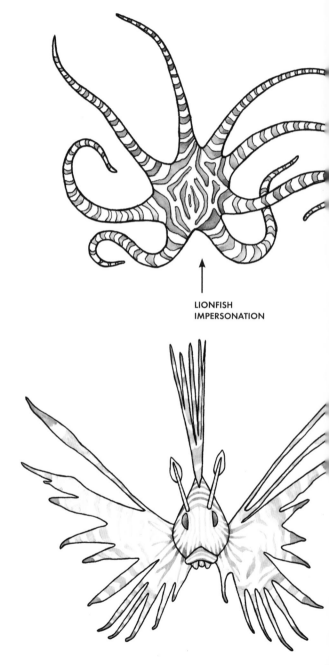

LIONFISH
IMPERSONATION

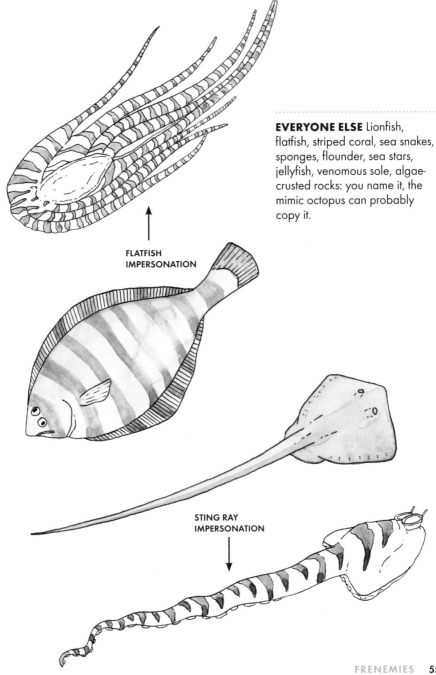

EVERYONE ELSE Lionfish, flatfish, striped coral, sea snakes, sponges, flounder, sea stars, jellyfish, venomous sole, algae-crusted rocks: you name it, the mimic octopus can probably copy it.

FLATFISH
IMPERSONATION

STING RAY
IMPERSONATION

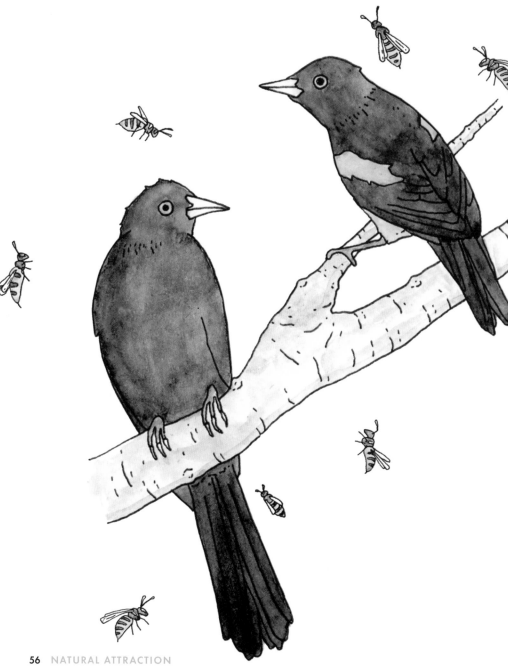

Protection by Proximity

YELLOW-RUMPED CACIQUE AND *POLYBIA REJECTA* WASPS

WHERE Central and South America

RELATIONSHIP STATUS The enemy of my enemy is my friend. Caciques are rowdy, but they're not entirely foolish. To protect themselves from pillagers, they often build their nests close to *Polybia* and other wasp colonies—within three or four feet. The wasps attack and drive off approaching predators—and for reasons no one quite understands, the insects seem to leave the caciques mostly alone.

The presence of the wasps also seems to protect the birds from the botfly—a nasty parasite that feeds on the flesh of newborn chicks—reducing botfly infection rates to near zero.

No one quite knows what the wasps get out of the relationship.

TAKEAWAY Nasty wasps make good neighbors.

YELLOW-RUMPED CACIQUE This slim, raucous tropical bird has a long tail, blue eyes, a pointed bill, and black plumage with a bright yellow rump and yellow "epaulets" on its wings. Gregarious, vocal creatures—the male's song is a vibrant mix of cackles, fluting notes, wheezing caws, and occasional mimicry—it gathers in large, noisy colonies that can be heard far across the forest. Living in close, crowded quarters for protection against the snakes, mammals (mostly primates), and larger birds like toucans that swoop in to eat their eggs (or chicks, or selves), caciques will assemble up to a hundred nests— bag-shaped, Dr. Seuss–like creations that hang from the ends of branches with strings of plant matter dangling off—in one large tree.

The cacique is depicted in Peruvian folklore as a rumor-mongering boy wearing black pants and a yellow jacket—a *paucarcillo*—who talks trash about the wrong fairy and gets metamorphosed into a noisy bird.

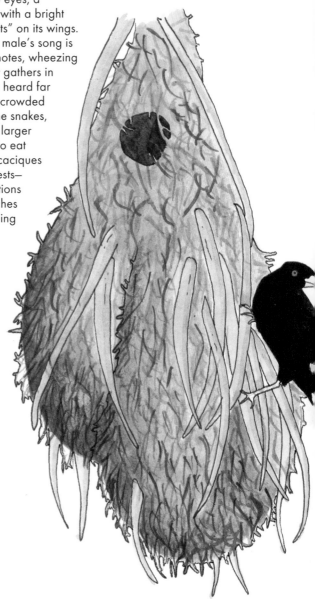

POLYBIA REJECTA WASPS These wasps are aggressive flying bullies that live with one massive queen in large "paper" nests made of wood pulp, resin, mud, and wasp saliva. They tend to set up housekeeping near water and especially like to eat the eggs of red-eyed tree frogs.

The *rejecta* in this particular species' name is fitting, because the wasps will reject (and attack) pretty much anything that gets within fifteen feet of their colony, delivering a wildly painful sting with little provocation—just getting close to the nest is enough.

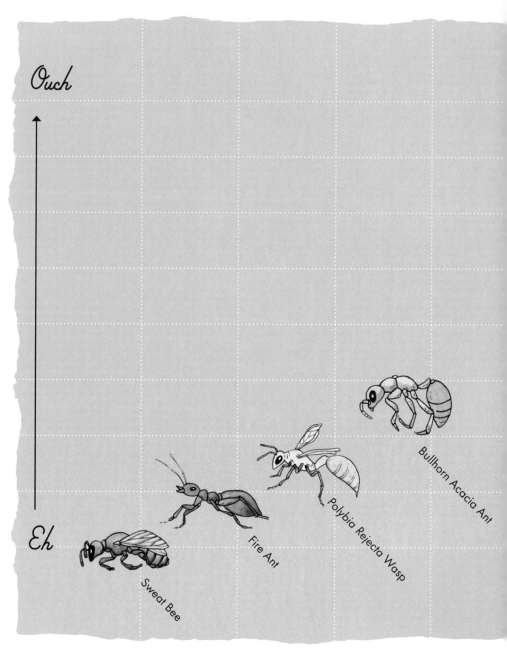

Ouch

Eh

Sweat Bee

Fire Ant

Polybia Rejecta Wasp

Bullhorn Acacia Ant

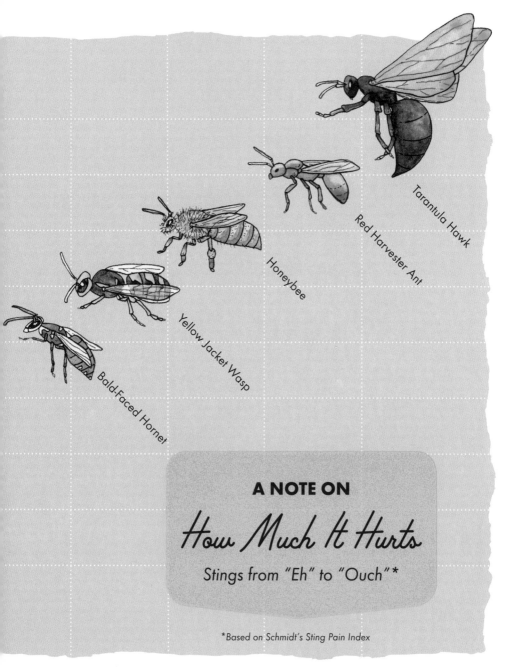

Tarantula Hawk

Red Harvester Ant

Honeybee

Yellow Jacket Wasp

Bald-Faced Hornet

A NOTE ON

How Much It Hurts

Stings from "Eh" to "Ouch"*

*Based on Schmidt's Sting Pain Index

Fish Is My Copilot

OCEANIC WHITETIP SHARK AND PILOT FISH

WHERE Deep oceans, mainly in warmer waters

RELATIONSHIP STATUS They like to hang. Pilot fish form a little gang around a shark and almost seem to be guiding—or piloting—it. When the shark eats a meal, the small bits of flesh and other debris that are strewn about become a feast for the pilot fish, which also use the shark as a swimming security guard.

As payment for protection and food, the pilot fish munch on the parasites and debris that collect on the shark's skin, helping it ward off infection and disease. They'll even swim into the shark's mouth to do a cleaning. This cleaning relationship is one of the basic mechanisms of symbiosis, which is why it pops up again and again.

Pilot fish form strong bonds with their individual shark and tend to be possessive of it, discouraging other fish from joining their posse.

TAKEAWAY They've got each other's backs. And fins. And teeth.

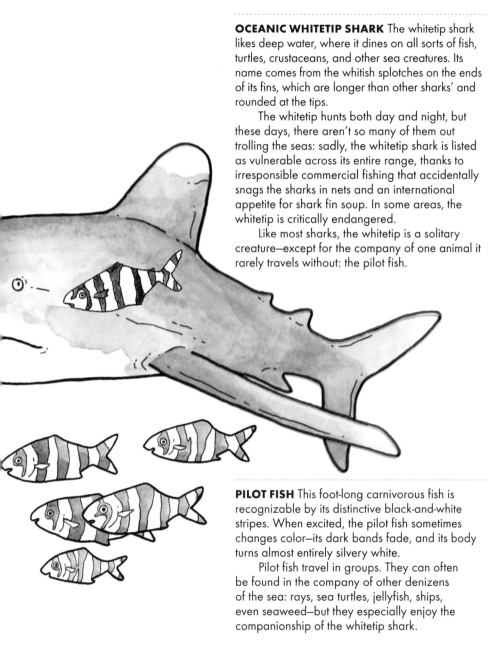

OCEANIC WHITETIP SHARK The whitetip shark likes deep water, where it dines on all sorts of fish, turtles, crustaceans, and other sea creatures. Its name comes from the whitish splotches on the ends of its fins, which are longer than other sharks' and rounded at the tips.

The whitetip hunts both day and night, but these days, there aren't so many of them out trolling the seas: sadly, the whitetip shark is listed as vulnerable across its entire range, thanks to irresponsible commercial fishing that accidentally snags the sharks in nets and an international appetite for shark fin soup. In some areas, the whitetip is critically endangered.

Like most sharks, the whitetip is a solitary creature—except for the company of one animal it rarely travels without: the pilot fish.

PILOT FISH This foot-long carnivorous fish is recognizable by its distinctive black-and-white stripes. When excited, the pilot fish sometimes changes color—its dark bands fade, and its body turns almost entirely silvery white.

Pilot fish travel in groups. They can often be found in the company of other denizens of the sea: rays, sea turtles, jellyfish, ships, even seaweed—but they especially enjoy the companionship of the whitetip shark.

RED CRAB SPIDER This red crab spider looks, well, sort of like a crab, scuttling sideways and backwards and holding prey in its large, pincerlike front legs. Though the crab spider produces silk like other spiders do, it doesn't build webs. It prefers the ambush: hunting, rather than trapping, its food.

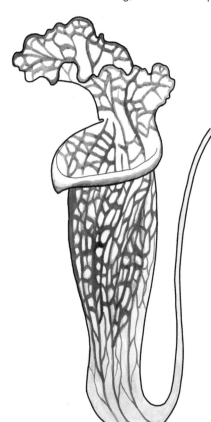

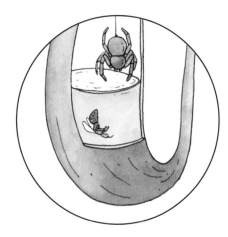

PITCHER PLANT This carnivorous plant grows in mineral-poor or acidic soil where normal photosynthetic plants can't survive. Instead of getting its nutrients from the soil through its roots, the pitcher plant lures unsuspecting insect prey. The plant is shaped like a water jug, with cupped leaves and a slippery rim. When insects land on the rim looking for nectar, they fall down the leaves' curved walls into a well, or "trap," with a pool of digestive juices at the bottom. The insect drowns in the liquid, which then dissolves its body.

A Hanger On

PITCHER PLANT AND RED CRAB SPIDER

WHERE Southeast Asia, India, Madagascar, and Australia
RELATIONSHIP STATUS Resident mooch. The red crab spider makes its home in the pitcher plant, using lines of silken thread to anchor itself to the leaves' interior walls. When an insect loses its footing and drowns in the plant's gastric juices, the spider lowers itself down, fishes the swamped bug out of the liquid, sucks out its internal organs, and leaves the carcass for the plant to digest.

If the insect falls so far under the pool's surface that the spider can't easily retrieve it, the spider pulls a ninja move: tethered to the safety of the upper plant by a silk string, it spins an air bubble around its mouth and uses it like a deep-sea diving helmet, submerging itself temporarily without drowning.

The pitcher plant doesn't get a whole lot out of the arrangement, but the spider does: instead of tracking down its targets, it just hangs tight and waits. And because the insects drown first, the spider gets to nosh on a much larger victim than it would be able to take down itself. It's like waiting for a seventy-two-ounce steak to drop in your lap.
TAKEAWAY Good things come to those who wait around in a carnivorous plant, hanging by a thread.

An Impostor with a Rude Habit

BLUESTREAK CLEANER WRASSE AND FALSE CLEANER FISH

WHERE Coral reefs in the Indo-Pacific

RELATIONSHIP STATUS False pretenses. The false cleaner fish mimics the wrasse, attracting cleaning customers with its wrasse-like stripe and dance moves. But this fish is no neat freak; it's a con artist. When a fish falls for the ruse and comes in for its cleaning, the impostor rips off the unsuspecting fish's scales or skin. The false cleaner fish acquires about a fifth of its calories this way. (The rest come from fish eggs and tubeworms.)

It's unclear just why the false cleaner fish has gone to such evolutionary trouble for only a fraction of its nutritional needs. It may be that the biggest benefit of the trickery is safety. By duping these bigger fish into thinking they're getting spruced up, they avoid being eaten. It's generally young, naïve fish that fall for the con.

TAKEAWAY Trust no one.

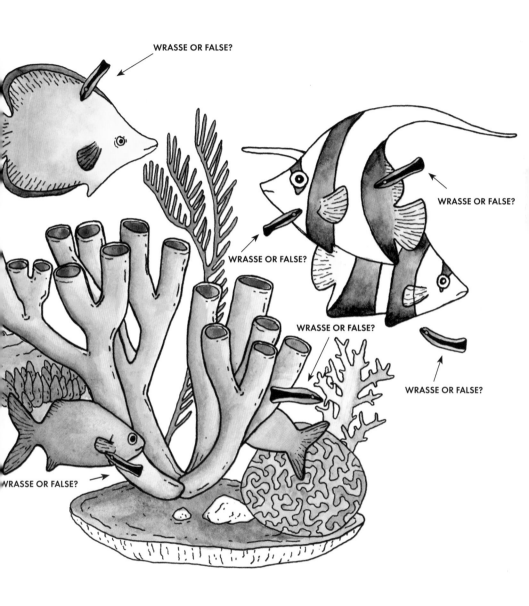

WRASSE OR FALSE?

WRASSE OR FALSE?

WRASSE OR FALSE?

WRASSE OR FALSE?

WRASSE OR FALSE?

WRASSE OR FALSE?

NO FANG

BLUESTREAK CLEANER WRASSE This small, streamlined fish has no distinguishable scales, but it does have a big black stripe running down the whole length of its four-inch-long, silvery-blue body. It eats nearly all its meals from the backs and mouths of other larger fish, doing a wriggling dance to induce the fish to visit its cleaning station.

It lives in groups with one dominant, mating male and a harem of smaller females. If the male dies, one of the harem members will switch sexes, grow in size, and take his place. But the most unusual thing about the bluestreak cleaner wrasse may not be its family structure but its doppelgänger.

FANG

FALSE CLEANER FISH The false cleaner fish is a species of combtooth blenny—small scaleless marine fish. Like the bluestreak cleaner wrasse, this fish also has a big black stripe running down the whole length of its four-inch-long, silvery-blue body, and it also shakes its body to induce grimy fish to visit its cleaning station. Unlike its twin, however, the blenny is equipped with a large fanged tooth.

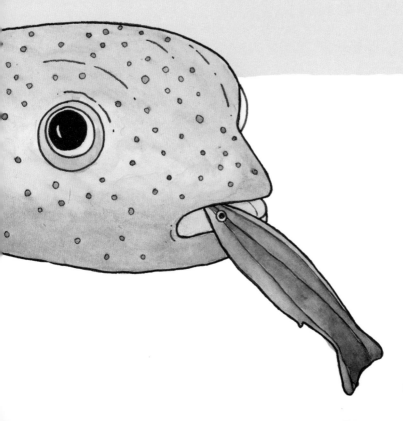

LYBIA CRAB This itty-bitty crustacean (one inch wide, max), with delicate, purple-banded legs and a mosaic of pink, brown, and white polygons adorning its carapace, is found in shallow waters under rocks and gravel flats and around coral. It is also known as the boxer, pom-pom, or cheerleader crab. More flimsily armored than most of its crustacean compatriots, with ineffectual pincers, the *Lybia* relies on bluster to defend itself.

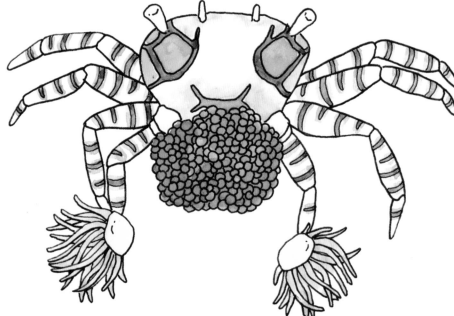

SEA ANEMONE Much smaller than their fellow species that house the clownfish, these anemones have adapted to latch onto living creatures (most anemones are permanently affixed to rocks or the sea floor). They, too, secrete toxins that stun fish and other passersby with a paralyzing neurotoxin, a useful asset for their carriers, the *Lybia* crab.

Fun fact: A sea anemone's mouth is also its anus.

Cheerleaders of the Sea

LYBIA CRAB AND SEA ANEMONE

WHERE Indian Ocean

RELATIONSHIP STATUS Passive-aggressive. *Lybia* crabs brandish small anemones—three different species of them— like pom-poms or boxing gloves, holding one in each claw as if ready, at any moment, to start caring about a sporting event. But it's not about being cute or encouraging: rather, the crabs are making themselves look larger and tougher by waving their anemone-laden claws at potential predators. If necessary, they'll also lash out with the toxic stingers. (Sometimes, enthusiasm can be deadly.)

Because the anemone foot suctions onto a flat section of the crabs' specially evolved claws, the stingers face away and the crabs avoid getting stung. The anemones get a fringe benefit too: the crabs carry them to new food sources and bring them to floating leftovers. But the crabs get the better end of the deal here.

The crabs are naked without their pom-poms: when they put down their anemone partners to molt, they pick them right back up, even before their shells have hardened. If they end up with only one pom-pom, they'll rip the single anemone in two, so there's still one for each claw. In the absence of anemones, the crabs will sometimes substitute sponges or corals to shake at the opposing team.

TAKEAWAY Enthusiasm kills.

A Debatable Friendship

RHINOCEROS AND OXPECKER

WHERE Southern and central Africa

RELATIONSHIP STATUS Deceptive. For many years, we humans believed that all was copacetic between the rhino and the oxpecker. We envied their attachment and mutual trust. The oxpecker rode on the rhino's back, pecking off earwax and small bugs. The rhino, in return, offered an endless ectoparastic feast. But recent evidence suggests that this mutualistic relationship is not so healthy after all.

Yes, the oxpecker removes parasites from the rhino's hard-to-reach spots. But while feasting, the birds often reopen the wounds the pests have created, exposing the rhinos to infection. Sometimes—true story—the oxpecker even dines directly on rhino blood. Oxpeckers may think they're doing rhinos a favor, but they often end up acting as parasites themselves.

Oxpeckers do bring one other thing to the friendship table, which may redeem them: when they see danger, they fly upward, shrieking a warning cry. This helps the rhino—which has terrible vision.

TAKEAWAY Beware of vampire friends.

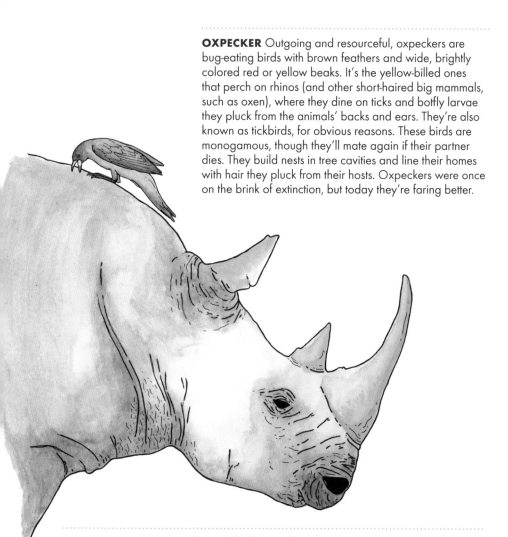

OXPECKER Outgoing and resourceful, oxpeckers are bug-eating birds with brown feathers and wide, brightly colored red or yellow beaks. It's the yellow-billed ones that perch on rhinos (and other short-haired big mammals, such as oxen), where they dine on ticks and botfly larvae they pluck from the animals' backs and ears. They're also known as tickbirds, for obvious reasons. These birds are monogamous, though they'll mate again if their partner dies. They build nests in tree cavities and line their homes with hair they pluck from their hosts. Oxpeckers were once on the brink of extinction, but today they're faring better.

RHINOCEROS A massive, horned herbivore that is not nearly as tough as it looks. Critically endangered in the wild, some species of rhino have been hunted to near extinction for their prominent horns. Rhinos have poor eyesight, relying primarily on smell and hearing to detect danger. And though the rhino's hide is thick and rough and plated like a suit of armor, it is incredibly sensitive to sunburns, insect bites, and cuts. To protect their skin from sun, rhinos rely on regular mud baths, which dry on their hide to form a protective layer.

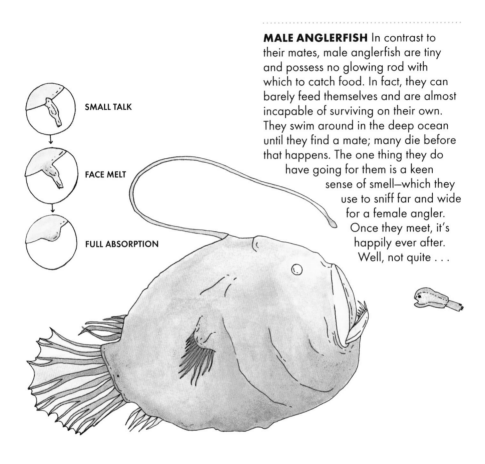

SMALL TALK

FACE MELT

FULL ABSORPTION

MALE ANGLERFISH In contrast to their mates, male anglerfish are tiny and possess no glowing rod with which to catch food. In fact, they can barely feed themselves and are almost incapable of surviving on their own. They swim around in the deep ocean until they find a mate; many die before that happens. The one thing they do have going for them is a keen sense of smell—which they use to sniff far and wide for a female angler. Once they meet, it's happily ever after. Well, not quite . . .

FEMALE ANGLERFISH Translucent, fleshy, and bulbous, with an oversize head, long transparent teeth, and a huge gaping mouth, these fish are terrifying. Their mouths and stomachs expand so that they can swallow prey twice their size. Their name comes from a part of their spine that sticks out from their foreheads like a big fishing rod. It's laced with bioluminescent bacteria and serves as a glowing lure to attract prey. Shining tendrils also hang from the fish's chin.

Attachment Issues

THE PARASITIC MATING OF ANGLERFISH

WHERE Deep down in the dark ocean

RELATIONSHIP STATUS Attached at the hip—or, rather, the stomach. Upon meeting, the male angler immediately bites and latches onto the female's underside in an awkward gesture of affection. Her flesh then releases an enzyme, which begins to dissolve the flesh around his mouth. He continues to dissolve into her, first his outer body and then his inner organs, until eventually they share bloodstreams. Soon he becomes little more than a bump attached to her side, a large gonad with the sole purpose of producing sperm to fertilize her eggs.

As if having your entire body dissolve until you're effectively a pair of testicles stuck to another fish isn't bad enough, this poor guy isn't even her one and only. Female anglerfish do this with up to eight males in a lifetime, all of them remaining a part of her body until she dies.

TAKEAWAY I'll stop the world and melt (all of my internal organs) with you.

Real-Life Ant Farms

ANTS AND APHIDS

WHERE *Everywhere*

RELATIONSHIP STATUS Milking it. Aphids have been referred to as "ant cows." Aphids suck sap, taking in nutrients from plants' vascular systems and secreting the excess sugars as a sweet substance known as *honeydew*. Ants *love* eating honeydew. So they milk the aphids. (Seriously.)

First, the ants emit chemicals from their feet to make the aphids cooperative (and if the aphids aren't, the ants bite off their wings to keep them from flying the coop). Then, the ants stroke the aphids' abdomens with their antennae. This elicits a droplet of honeydew on the aphid's back, which the ant collects for the colony or sucks up itself. Ants even train their aphid herds, conditioning them to produce honeydew on demand. And if the aphids don't produce, the ants eat them instead.

The aphids do get a little something in return: protection. Ants shelter aphids and their eggs in their underground nests, attacking insect predators, carting away infected aphids to prevent mass contamination, and even leading aphids to the ripest food sources. But it's a manipulative move that keeps the aphids around to put out more honeydew. When an ant queen leaves to start a new colony, she will often bring along several aphid calves to ensure a herd of her own.

TAKEAWAY Moo.

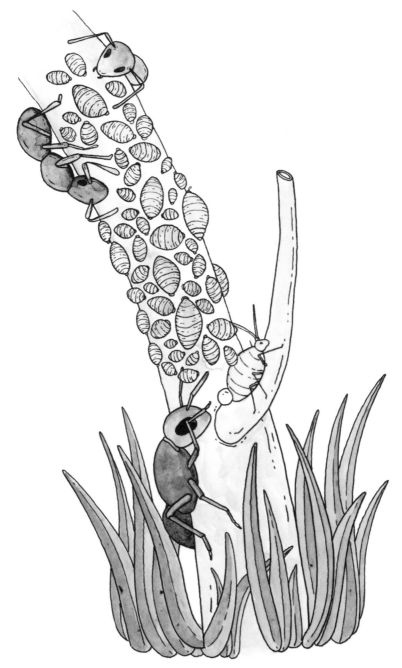

ANTS As anyone with a kitchen knows, ants are hard to miss and even harder to avoid: an estimated twenty-two thousand species have so far been classified on every landmass on earth except Antarctica and a few desolate islands. Most live in colonies ruled by one or more fertile, winged queens and populated by millions of sterile, wingless workers or soldiers that keep the place running. Their colonies are often described as "superorganisms," with each individual possessing limited intelligence but the complex system as a whole functioning flawlessly and efficiently. Ants can accomplish a lot as a team: they build, they dig, they communicate, they solve complex problems, they fight, and they also farm.

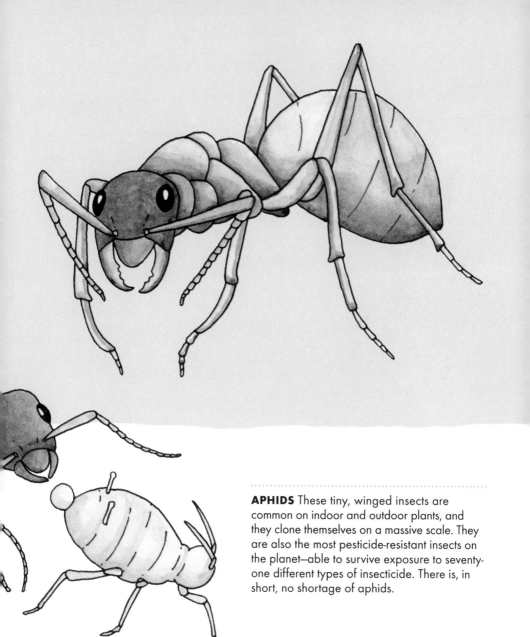

APHIDS These tiny, winged insects are common on indoor and outdoor plants, and they clone themselves on a massive scale. They are also the most pesticide-resistant insects on the planet—able to survive exposure to seventy-one different types of insecticide. There is, in short, no shortage of aphids.

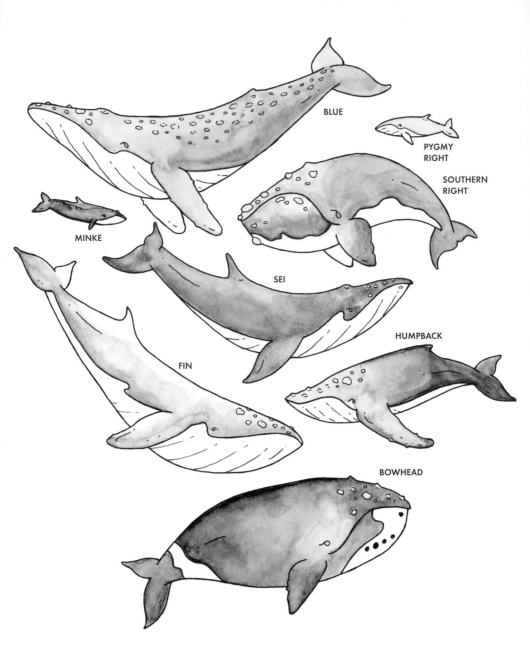

BLUE

PYGMY
RIGHT

SOUTHERN
RIGHT

MINKE

SEI

HUMPBACK

FIN

BOWHEAD

In It for the Long Haul

BALEEN WHALE AND BARNACLES

WHERE All oceans

RELATIONSHIP STATUS Set in cement. Barnacles begin life as free-floating larvae, generally in the same warmer waters whales use to breed. Once they meet a whale, the baby barnacles climb on board and latch on with a cement-like substance they secrete. And *voilà*—a permanent mobile home! Happily attached to the whale's skin, they get oxygen and nutrients from the water flowing past as the whale swims, using their little feathery legs to gather plankton.

For some whales, the barnacles' tough, scaly shells become a suit of armor, protecting them from a vicious predator—a killer whale out for a meal. Certain types of baleen whales can speed away from the killers. But other species—including humpback, right, bowhead and gray whales—move too slowly to outrun them and may have to fight. The barnacle armor may just save their lives. But a barnacle suit is heavy. Whales can cart around up to a thousand pounds' worth of the little crustaceans. That's like wearing a stone shirt you never get to take off.

In an extra-cool twist, scientists are studying fossil barnacles from the Ice Age to learn about whales' migration routes. Follow the barnacles, follow the whales.

TAKEAWAY Stuck on you. Forever.

BALEEN WHALE Baleens—a suborder of whales that includes the right whale, pygmy right whale, gray whale, and rorqual families—are toothless with stiff, sieve-like plates that hang from their upper jaws to catch krill, plankton, and small fish. They are also huge: the blue whale, a baleen species, weighs up to 190 tons and is the largest creature on earth. And they are peripatetic and loquacious, migrating throughout the planet's oceans and singing songs to communicate with each other. Their songs are one of the most complex forms of communication outside of human language; it has been observed that their music of choice changes seasonally, like pop songs moving in and out of popularity. They filter food from the water, surface to breathe, and stay warm with a nice coating of blubber.

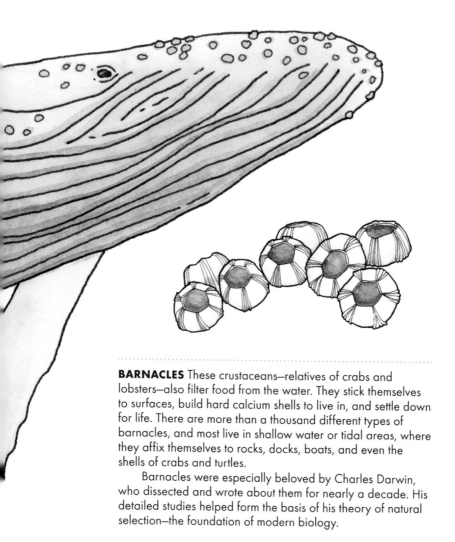

BARNACLES These crustaceans—relatives of crabs and lobsters—also filter food from the water. They stick themselves to surfaces, build hard calcium shells to live in, and settle down for life. There are more than a thousand different types of barnacles, and most live in shallow water or tidal areas, where they affix themselves to rocks, docks, boats, and even the shells of crabs and turtles.

Barnacles were especially beloved by Charles Darwin, who dissected and wrote about them for nearly a decade. His detailed studies helped form the basis of his theory of natural selection—the foundation of modern biology.

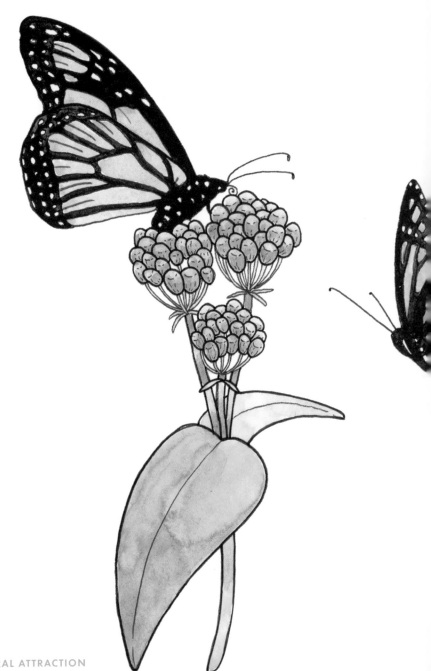

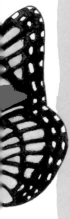

Tasteless Copycats

MONARCH AND VICEROY BUTTERFLIES

WHERE North America

RELATIONSHIP STATUS Matchy-matchy. If either butterfly floated past you, you'd be hard-pressed to tell them apart: both have almost exactly the same orange-and-black pattern on their wings, though the viceroy is smaller, flies in a more erratic pattern, and has one extra black stripe across each hind wing.

Where the two species differ is in their behavior. Monarchs migrate from the northern United States and Canada all the way down to Mexico and back each year, laying their eggs on milkweed plants before they hit the road. Milkweed is toxic to most animals. Not to monarchs though—they love the stuff. Monarch caterpillars consume scads of it, growing up to 2,700 times their birth size in less than a month, and the plant toxins remain in the insects' systems long after they metamorphose into butterflies. That keeps predators—birds and wasps, mainly—away.

Viceroys stay in one place—their range extends from central Canada to northern Mexico—and their caterpillars feed not on milkweed but on willows, poplars, and cottonwoods.

For many years lepidopterists thought that the viceroy's physical similarities to the monarch represented a classic example of Batesian mimicry—where harmless species evolve to resemble poisonous or foul-tasting ones in order to fool predators into thinking that the harmless mimics are also dangerous.

Scientists believed that the viceroy, by looking like a monarch, tricked predators into staying away. But, in fact, the salicylic acid from the trees on which the viceroy feeds also upsets predators' stomachs, and they now believe that the viceroy tastes even worse to predators than the monarch. So it's more likely that the two species of butterflies copy each other. This is called Müllerian mimicry, in which two noxious species find survival benefit by evolving to look alike.

TAKEAWAY Imitation (of a bad-tasting friend) is the sincerest form of flattery.

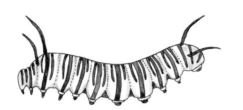

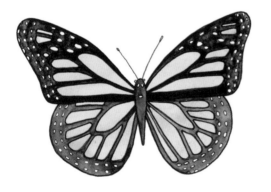

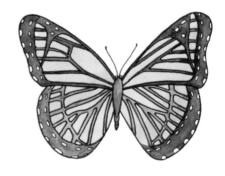

MONARCH BUTTERFLY
An orange-and-black
butterfly that soars through
the American heartland
and is toxic or bitter
tasting to many predators.

VICEROY BUTTERFLY
An orange-and-black
butterfly that soars through
the American heartland
and is toxic or bitter
tasting to many predators.

YUCK

MÜLLERIAN MIMICRY Different species of unpalatable or poisonous animals evolve to closely resemble one another to reduce overall predation. When multiple species are involved, it becomes a mimicry ring.

TIGER PATTERN MIMICRY RING

YUCK

YUCK

A NOTE ON

Mimicry

Natural Posers

EASTERN CORAL SNAKE
(VENOMOUS)

BATESIAN MIMICRY
A species that is palatable and not poisonous evolves to resemble one that is, in order to avoid and trick predators.

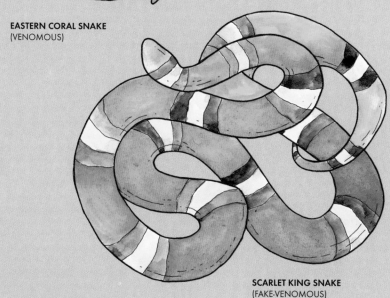

SCARLET KING SNAKE
(FAKE-VENOMOUS)

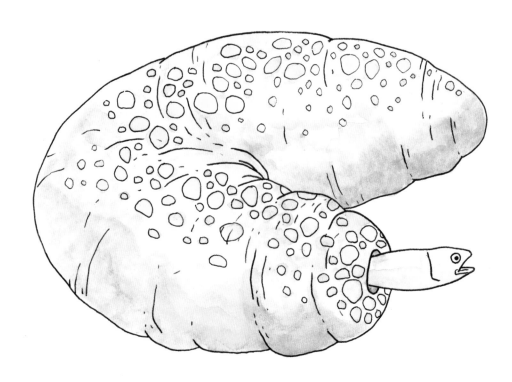

Bad at Boundaries
PEARLFISH AND SEA CUCUMBER

WHERE Deep oceans

RELATIONSHIP STATUS Truly bizarre. Some species of pearlfish have hit upon an unlikely habitat—the sea cucumber's anus. Drawn there by the currents of water created by the cucumber "breathing" in and out, the six-inch-long pearlfish darts in, back-end first, through the cucumber's cloaca when it's open. This way, it can still see what's up in the sea outside. There it stays, safely hidden away, until nightfall.

But sometimes the pearlfish isn't simply sitting still. It will eat the sea cucumber's insides—especially its gonads. When this happens, the cucumber will use a neato self-evisceration technique to purge the pearlfish (and its internal organs, which it will then regrow).

Some cucumbers have a zero-tolerance policy for the fishy freeloaders. These lucky species have evolved anal teeth—an excellent way to signal that their personal orifices are off-limits to outsiders.

TAKEAWAY Beware cloaca-and-dagger operations.

SEA CUCUMBER These strange invertebrates are elongated, cucumber-shaped, soft-bodied members of the echinoderm family—relatives of starfish and urchins. Like earthworms of the ocean, they help break down and recycle all sorts of marine particles, from algae to fish poop, creating nutrients for bacteria to then feed on. Sea cucumbers breathe water—in through the mouth and out through the anus, or cloaca—collecting these tiny food particles in the process. Small, tentacle-type feet help them move across the sea floor and gather food. Most sea cucumbers are smaller than a foot long, but the biggest species can grow to nearly ten feet.

When threatened, some sea cucumbers lash out by expunging their internal organs. That's right—they eviscerate themselves, expelling their intestines out their anuses. You'd have to be a pretty desperate predator to stick around after that.

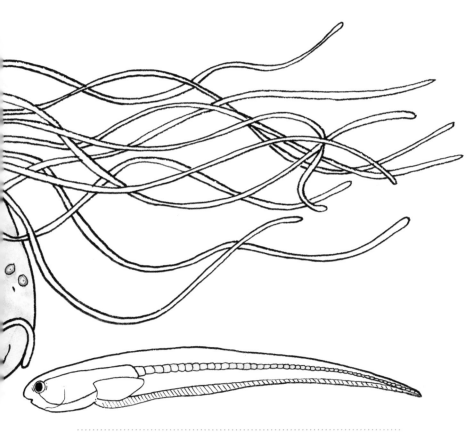

PEARLFISH This slender, translucent, eel-shaped tropical fish has no scales and takes advantage of its sleek body to live where other fish cannot go: inside the bodies or body cavities of other sea creatures. Its name hails from the site—and state—in which humans first discovered it, inside the shell of an oyster, dead and turned to pearl.

Pearlfish hide inside their chosen orifices during the day, emerging at night to hunt.

Part 3

ENEMIES

Parasitism

Parasitism is a lousy deal. For those on the wrong end of this sort of relationship, it often quite literally sucks—the blood, the energy, and the life out of the unfortunate parasitized creature (though it's in the best interest of the parasite to keep its host alive for as long as possible so as to reap the benefits longer).

Nature is full of parasites: plants, animals, and fungi. There are ectoparasites, which live on other organisms' skin or hair; endoparasites, which live inside their victims; kleptoparasites, which steal food; and social parasites, which cheat or steal from other species or even lesser-ranking individuals of their own kind.

Parasitic relationships come in a wide range of styles. Some are sad; some are weird; some will keep you up at night.

ROUGH-SKINNED NEWT AND GARTER SNAKE

WHERE Western North America

RELATIONSHIP STATUS Toxic. The garter snakes won't let a little poison—or a lot of poison—interfere with their taste for newts. As a result, garter snakes—which themselves secrete a poison, though a far milder one, in their saliva—have been locked in an evolutionary arms race with the newts for eons. The snakes develop resistance to the toxin, and in response, the newts evolve to secrete ever-greater concentrations of the poison.

Indeed, some rough-skinned newts can now produce enough poison to kill thousands of mice or up to twenty humans: but it's not enough. The snakes still scarf them down, and the newts simply can't hold any more of the toxin in their skin glands. Yet.

TAKEAWAY 'Til death (by toxic overload) do us part.

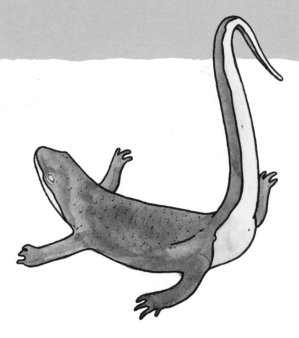

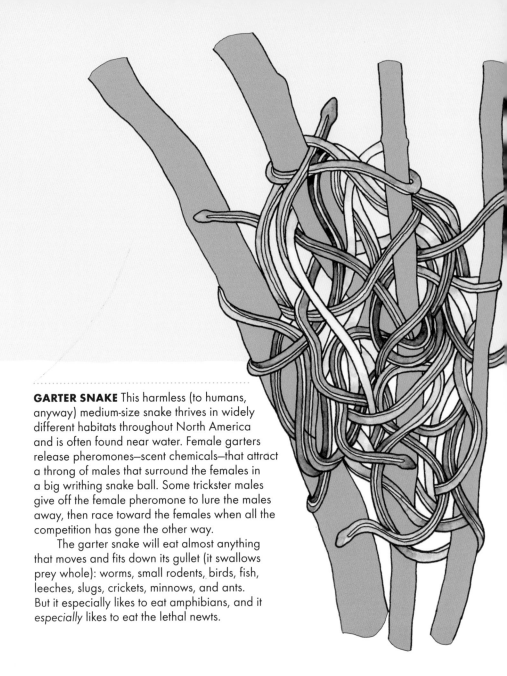

GARTER SNAKE This harmless (to humans, anyway) medium-size snake thrives in widely different habitats throughout North America and is often found near water. Female garters release pheromones—scent chemicals—that attract a throng of males that surround the females in a big writhing snake ball. Some trickster males give off the female pheromone to lure the males away, then race toward the females when all the competition has gone the other way.

The garter snake will eat almost anything that moves and fits down its gullet (it swallows prey whole): worms, small rodents, birds, fish, leeches, slugs, crickets, minnows, and ants. But it especially likes to eat amphibians, and it *especially* likes to eat the lethal newts.

ROUGH-SKINNED NEWT Do not try to eat one of these. Seriously, do not try to eat one of these. Like, not even if you're really hungry. Not even on a dare. One twenty-nine-year-old guy did just that, and he keeled over dead.

These midsize salamanders, brown on top with bright yellow or orange bellies, are among the most toxic animals on the planet. When threatened, the newts curl up their tails and arch their necks, flashing their bellies as a back-off-I'm-poisonous signal. And, boy, are they poisonous: the newts have evolved high levels of a potent toxin in their skin glands. Called *tetrodotoxin*, or TTX, the poison is a neurotoxin, the same one found in deadly pufferfish. It quickly paralyzes and often kills those unfortunate or unwise enough to ingest it. Even newt eggs—a delicacy for carnivorous insects—contain the toxin.

These newts breed in the water, with a male grabbing onto a female's back via special "nuptial pads" on his toes that only form during breeding season.

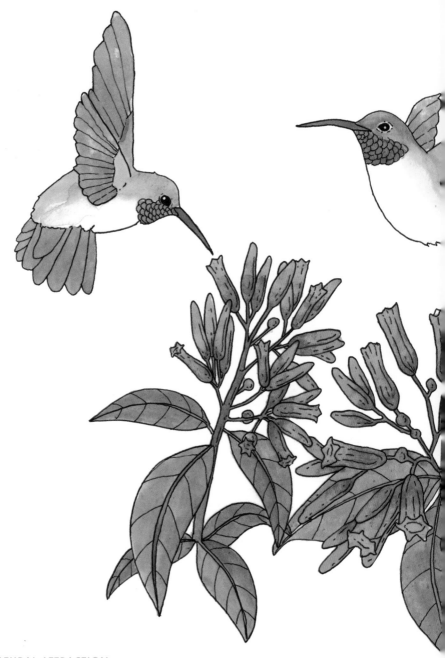

Nose-Riding Freeloaders

HUMMINGBIRDS, FLOWER MITES, AND HAMELIA FLOWERS

WHERE American tropics and subtropics

RELATIONSHIP STATUS Rapid transit for mites. As a hummingbird hovers over a hamelia flower, collecting nectar and spreading pollen, mites scamper into the bird's nasal cavity, where they catch passing scents as the bird breathes in and out. Different species of mites feed on different species of flowers, though many types of mite will share the same bird nostril. When those tiny passengers smell the right flower (mites have no eyes; they operate by smell and feel), they make a mad dash down the beak of the bird to dismount.

It's a good arrangement for the mites, but pretty lousy for the other parties in this airborne triad: the mites, while tiny, crowd into flowers by the dozens, eating as much as a full-grown bird, competing with their hummingbird hosts, and reducing the flower's capacity for pollination.

TAKEAWAY Two's company, three hundred's a crowd.

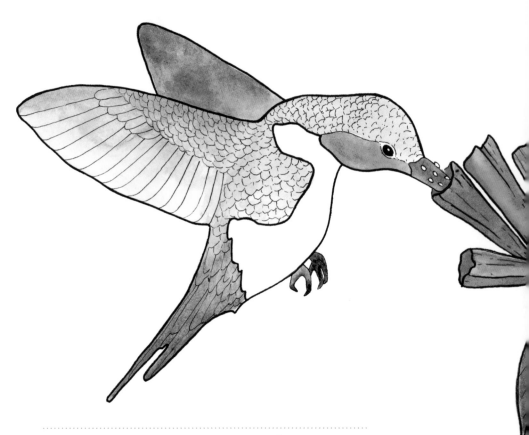

HUMMINGBIRDS These tiny birds are named for the high-frequency hum they make as they fly from flower to flower, hovering and flapping their wings in a figure-eight motion at a rate of fifty times per second. The largest species of hummingbird is about five inches long; the smallest measures two inches and weighs less than a penny. Hummingbirds consume more than their weight in nectar each day and have the highest metabolism of almost any animal. When food is scarce, they go into a state called *torpor* to preserve energy, slowing their metabolism to one-fifteenth of normal. When flying—as fast as thirty-five miles per hour, forwards and backwards—their hearts can beat at a rate of 1,260 beats per minute.

FLOWER MITES Disagreeable things come in small packages: only two-hundredths of an inch long, these tiny insects are known as nectar robbers because they can devour up to 40 percent of a flower's available nectar and 50 percent of its pollen. Then they mate, lay a ridiculous amount of eggs, and head to the next blossom—moving at a rate of twelve body lengths per second, the same relative speed as a cheetah. But they can't get to faraway flowers without a lift.

HAMELIA FLOWERS These large shrubs or trees in the coffee family are also known as *firebushes* or *redheads*. Hamelia flowers are recognizable by their long, thin orange-red flowers, which are perfectly adapted for long, thin hummingbird beaks.

SAND TIGER SHARK They get a head start. Embryos employ cannibalism in utero with the largest one eating all but one sibling. The two remaining siblings grow up to be larger and stronger due to the lack of competition for uterine resources. This sibling rivalry results in proportionally larger babies than other shark species.

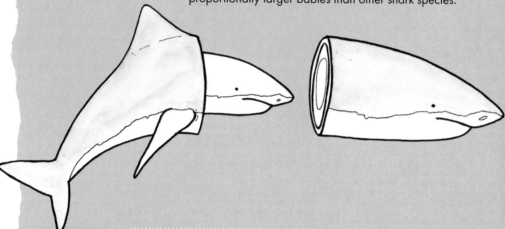

HAMSTER Hamsters are basically like fuzzy potatoes, but they need a lot of personal space and will eat their territory rivals or newborn babies.

A NOTE ON

Cannibals of the Animal Kingdom

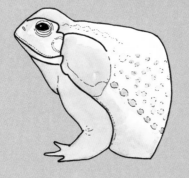

CANE TOADS Cane toad tadpoles eat the eggs of their own species, using chemical sensors to detect them nearby.

TIGER SALAMANDER Some babies turn out normal, and some morph into big-headed, sharp-toothed cannibals. Salamanders that grow up around their kin are less likely to develop a taste for them.

Floating Interdependence

SEA OTTERS, SEA URCHINS, AND KELP

WHERE Pacific Ocean

RELATIONSHIP STATUS Splendor in the kelp—when all is in balance, that is. Kelp protects otters; otters eat urchins; urchins eat kelp. Without otters to keep them in check, the urchins go crazy, devouring entire kelp forests and turning these once-thriving ecosystems into "urchin barrens"—full of urchins and nothing else. The loss of the forests in turn causes other species to crash. It's a cascade of destruction, and a perfect example of natural balance. Mess with one part of the system and the whole thing may fall apart.

TAKEAWAY Kelping each other out.

SEA URCHINS Small, spiky, ancient, brainless, omnivorous lumps, sea urchins move along the seafloor in search of meals, using foot-like suction cups to propel themselves forward and help gather food. To avoid predators, sea urchins hide in rock nooks and munch on the scraps and remnants of kelp plants.

KELP Kelp is a vital part of marine ecosystems, offering food and shelter for fish and other ocean creatures, including otters, that wrap themselves in the plants' leaves to sleep so they can stay afloat without drifting away. These underwater forests function much like aboveground forests and are essential for sequestering CO_2 from the atmosphere.

SEA OTTERS These playful, fuzzy water weasels are unique among marine mammals: unlike whales, seals, and walruses, they actually have paws. This lets them skillfully turn over rocks to find food and crack open shellfish—which they do while lying on their backs, using their bellies like a countertop. Otters have the thickest fur of any mammal—land or sea—which unfortunately left them hunted nearly to extinction in the 1800s. Today, they've made a significant comeback.

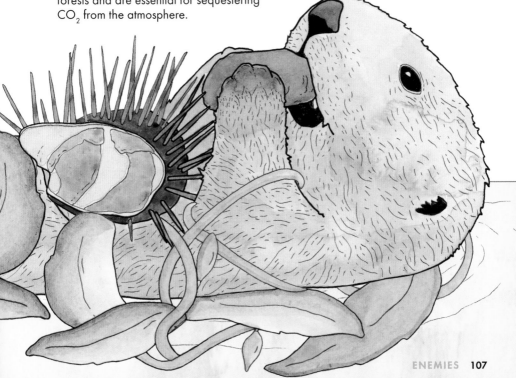

OPHIOCORDYCEPS FUNGUS This ancient, highly specialized parasitic fungus has evolved to infect individual species of ants as well as other insects, using them to incubate and spread spores. Scientists suspect that these fungi have been altering behavior in ants since before the continents split apart: a forty-eight-million-year-old fossilized leaf found in Germany shows scars from an ant bite that suggest the insect had been possessed by a forty-eight-million-year-old fungus.

FUNGAL SPIKES

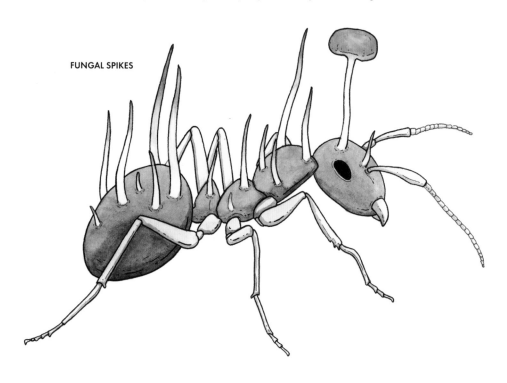

CARPENTER ANTS Up to one inch long, these big forest ants build nests by chewing tunnels and galleries in damp, decaying, or hollow wood. The ants don't eat the wood; they just live in it. For food, they forage dead insects, and when they find one, they surround it and extract its bodily fluids, leaving the desiccated exoskeleton behind. Yum.

Living Dead

OPHIOCORDYCEPS FUNGUS AND CARPENTER ANTS

WHERE Tropical forests worldwide

RELATIONSHIP STATUS Not a healthy bond. The fungus takes over the insect's nervous system upon encounter with a spore: first, the ant stumbles and walks in circles. Then, it climbs above the forest floor and bites the main vein on a leaf's underside. Carpenter ants don't normally bite leaves; this is the fungus having its way, and because the fungus has also eaten away at the muscles around the ant's mandible, the ant can't let go: it is stuck there in a literal death grip.

Now, the fungus eats the ant's internal organs and tissues from the inside out. The ant dies within six hours; two or three hours later, a fungal stem sprouts from the back of the dead ant's head, grows into a stalk, and releases its spores to the ground below, where the cycle of zombification and head-gardening begins again.

The ants do have some defenses: a colony's workers recognize infected zombies and carry them away before the fungus can spread within the nest, preventing mass carnage. There's also another fungus that parasitizes the parasite, stifling the release of zombie-spores by essentially sitting on top of the fungus, thus ensuring that sufficient ant populations survive to host future fungi sandwiches.

TAKEAWAY So. Manipulative.

Serious Control Issues

JEWEL WASP AND AMERICAN COCKROACH

WHERE South Asia, Africa, and Pacific Islands
RELATIONSHIP STATUS Ruthless and self-serving. The female wasp swoops in on an innocent cockroach, wrestles it into position, then stings a very specific spot on its throat, which paralyzes the roach's front legs. A second set of stings, near the roach's brain, stuns it into submission. The wasp chews off half the roach's antennae, takes a quick drink of its hemolymph (bug blood), then pulls her victim by one antenna into her burrow, where the wasp lays one white egg on the roach's abdomen, seals the burrow entrance with small pebbles, and heads off to find more roaches to torture.

Back in the lair, the egg hatches into a larva, which drills into the still-breathing roach and eats its insides, saving the vital organs for last, to keep its host alive as long as possible. It then spins a cocoon and secretes an antibacterial substance to coat the walls of the roach's hollowed-out body. The full-grown wasp emerges days later, eats its way out of the roach, and flies off.
TAKEAWAY They'll eat you alive.

AMERICAN COCKROACH Skittery, resilient, red-brown, and winged, this is the scavenging insect that everyone loves to hate. At nearly one and a half inches long, the American is the largest of the common cockroach species, though it doesn't actually come from the Americas—it originated in Africa and first arrived in North America on Spanish treasure vessels as early as 1625. Now, it's ubiquitous. It's fast too: scientists have clocked the American cockroach running up to fifty body lengths per second, which is comparable to a human sprinting at 210 miles per hour, and then squeezing under a door crack without breaking stride. Cockroaches date back some 350 million years and seem capable of fending off almost every nasty twist that nature throws their way—everything, that is, except a certain emerald-green wasp.

JEWEL WASP This solitary wasp is also known as the emerald cockroach wasp, both because of its brilliant metallic blue-green body and because of the horrible things it does to cockroaches.

VAMPIRE BATS The only mammals that feed entirely on blood, vampire bats sleep all day hanging upside down in totally dark caves—one hundred to one thousand bats in a colony—and emerge at night to feed. These legendary critters are the stuff of horror tales, but they're actually quite cute. Not only can they fly, they can also walk and even run on four limbs, using their wings like crutches and propelling themselves into the air with a jump, thumbs last.

The bats are also very civilized. They're one of the only animals besides humans known to reciprocate a kind gesture: in this case, blood-sharing. Vampire bats drink blood. Then, sometimes, they puke it back up in another bat's mouth: true generosity. This is how they feed their young (though the baby bats also drink their mothers' milk), and also how they bond with other bats they want to get to know. Then, when the chance arises, that recipient bat returns the favor, puking up some of its own hard-won blood for the generous friend. Bats often also help feed new vampire moms. It's like bringing lasagna to a neighbor . . . if every single ingredient was blood.

LIVESTOCK
Chickens, cows, horses, sheep, pigs, goats: no warm-blooded creature is safe from a hungry vampire.

A Bloodbath

VAMPIRE BATS AND LIVESTOCK

WHERE Central and South America

RELATIONSHIP STATUS Out for blood. Sensors on the bats' noses direct them to the warmest, bloodiest bits of their victims, and then the bats dig in. They use their sharp teeth to make a small cut and then lap up the meal with their tongues. An anticoagulant in the bats' saliva helps the blood keep flowing so the blood loss itself doesn't harm the livestock—however, fatal infections and diseases aren't uncommon.

There are three species of vampire bats, and each has a slightly different menu preference. The common vampire bat eats everything: birds, mammals—blood is blood. The white-winged vampire bat is somewhat fussier. Though it dines on both birds and mammals, it loves goats most of all—and it has a thing against cows, avoiding them if possible. The hairy-legged vampire bat, meanwhile, eats only the blood of birds, pretending to be a chick so the mama bird will sit on it, allowing it easy access to the dense blood vessels on her underside. It likes hens best: its delicacy of choice is the blood of a chicken's large backward-facing toe.

TAKEAWAY They've got blood on their hands—and noses, and teeth, and tongues.

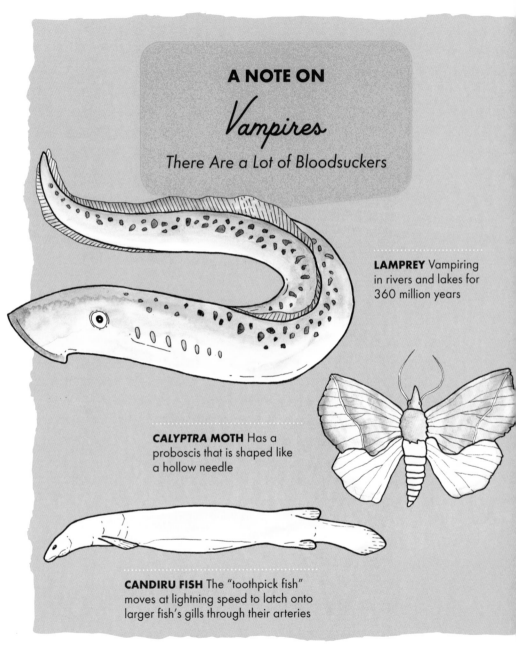

A NOTE ON

Vampires

There Are a Lot of Bloodsuckers

LAMPREY Vampiring in rivers and lakes for 360 million years

CALYPTRA MOTH Has a proboscis that is shaped like a hollow needle

CANDIRU FISH The "toothpick fish" moves at lightning speed to latch onto larger fish's gills through their arteries

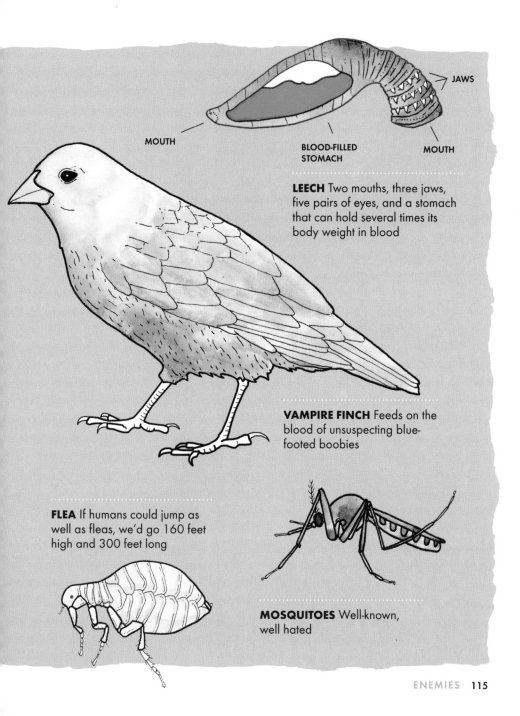

MOUTH

JAWS

BLOOD-FILLED
STOMACH

MOUTH

LEECH Two mouths, three jaws, five pairs of eyes, and a stomach that can hold several times its body weight in blood

VAMPIRE FINCH Feeds on the blood of unsuspecting blue-footed boobies

FLEA If humans could jump as well as fleas, we'd go 160 feet high and 300 feet long

MOSQUITOES Well-known, well hated

Louse Got Your Tongue

TONGUE-EATING ISOPOD AND THE LEAST-LUCKY FISH OF ALL TIME

WHERE All oceans

RELATIONSHIP STATUS Macabre. So gross it's hard to even describe. This pale, six-legged crustacean sets up shop in a poor fish's mouth, securing itself by anchoring its feet in the fish's gills. After getting cozy, the isopod begins to suck the blood from the fish's tongue. This uncomfortable process continues until the tongue shrivels up, loses function, and dies. Eventually it falls off, leaving the perfect spot for the isopod to take up permanent residence.

Only female isopods do this hideous deed, but all isopods are actually born male. They swim in groups into the gills of a fish and mature there—and ultimately one male switches sex. That female loses her eyesight and quickly grows big, eventually invading the fish's mouth and settling in.

Once installed, the isopod feeds off parts of the fish's meal, particularly blood and mucus.

There are hundreds of known species of tongue-eating isopods—and who knows how many more we haven't yet met.

TAKEAWAY Isopod got your tongue?

TONGUE-EATING ISOPOD Often referred to as a "marine louse," this crustacean species is nothing like the lice that set up house on people's scalps. Growing up to an inch or more in length, the tongue-eaters bring far worse news for their hosts than a possible shaved head. Isopods are a group of creatures with segmented exoskeletons (think of those soil-dwelling roly-poly bugs); some live on land, some in the ocean. The tongue-eating ones give the rest a bad name.

INTRUDER

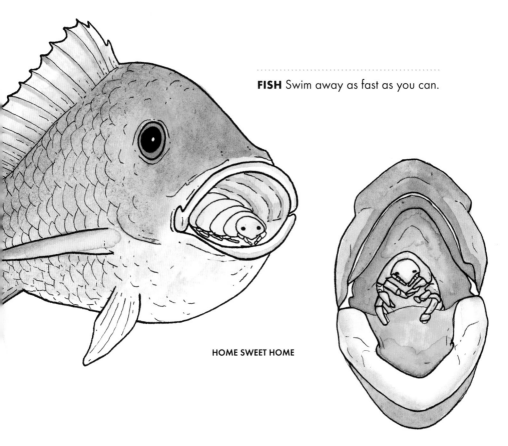

FISH Swim away as fast as you can.

HOME SWEET HOME

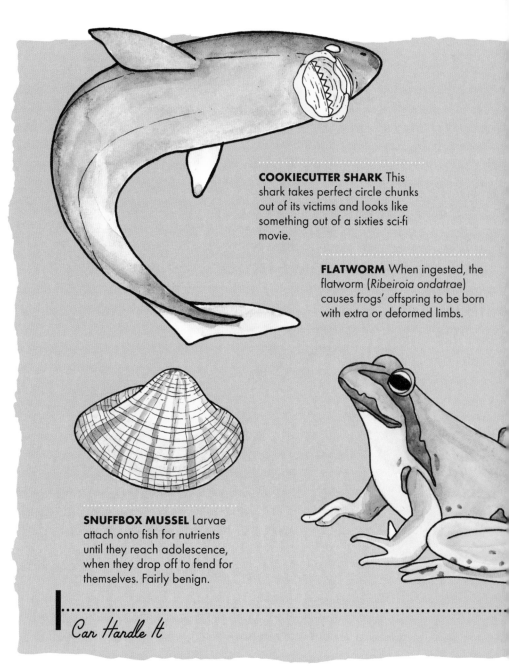

COOKIECUTTER SHARK This shark takes perfect circle chunks out of its victims and looks like something out of a sixties sci-fi movie.

FLATWORM When ingested, the flatworm (*Ribeiroia ondatrae*) causes frogs' offspring to be born with extra or deformed limbs.

SNUFFBOX MUSSEL Larvae attach onto fish for nutrients until they reach adolescence, when they drop off to fend for themselves. Fairly benign.

Can Handle It

BEDBUGS Bedbugs can survive in temperatures from below freezing to 120 degrees F and can go months without feeding. If you find your home infested, you might have to burn everything.

TAPEWORM They can live in human intestines for decades, growing dozens of feet long. Females release up to a million eggs a day.

BOTFLY The fly lays its eggs beneath the skin of mammals or humans. The growing larva eventually creates a wound that resembles a boil, out of which a fully developed fat maggot wriggles.

Nauseating

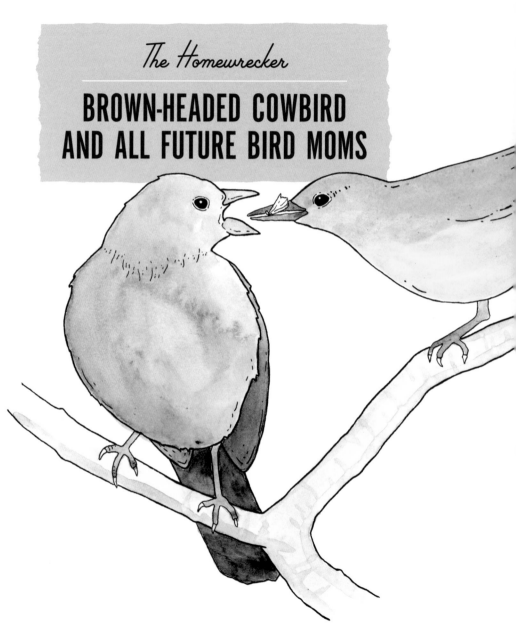

The Homewrecker

BROWN-HEADED COWBIRD AND ALL FUTURE BIRD MOMS

WHERE Temperate to subtropical North America
RELATIONSHIP STATUS An unfair trade. During laying season, the female cowbird scopes out nesting female birds of other species. She lurks around their nests, keeping a low profile and waiting for the bird to fly off on an errand, then removes one or more eggs from the host's nest, piercing them with her beak or dropping them away from the nest. Then she replaces the eggs with her own. None the wiser, the bird returns, plops her warm duff on the cowbird eggs, and gets down to the business of incubating another mother's chick.

This is called *brood parasitism*, and while it works for the cowbirds, it's tough on the other species. Not only do cowbirds destroy the other bird's hard-laid eggs; their hatchlings also outcompete her young. Because cowbird eggs have short incubation periods, they often hatch first and thus are first to be fed, growing faster, demanding more food, and gaining early advantage over their nest-mates. Cowbird moms are also homewreckers in a literal sense: they come back periodically to check on their young, and if the foster mom has removed the trespassing egg, the cowbird takes revenge, ransacking the poor bird's nest. Thus it's often in the bird mom's best interest to suck it up and raise the cowbird as her own. They call this *mafia behavior*.
TAKEAWAY Put your eggs in somebody else's basket. If they won't take your eggs, destroy the basket.

OTHER
BIRD MOMS

GRAY CATBIRD

CAROLINA
WRENS

SWALLOW

WOOD
NUTHATCH

GREAT
CRESTED
FLYCATCHER

BLUE-GRAY
GNATCATCHER

FEMALE

MALE

BROWN-HEADED COWBIRD This stout, noisy, thick-headed blackbird roams North America's open grasslands, munching on the insects kicked up by roving livestock. Back before European settlement, the cowbird was likely to be found hanging around a herd of bison; today, it follows horses and cows. Such a nomadic lifestyle was tough for raising young, because the laying mothers weren't stationary long enough to incubate eggs. So instead of building nests for their young, cowbird females lay lots and lots and lots of eggs—sometimes more than three dozen each summer—and dole them out to others.

FUTURE BIRD MOMS From the common cardinal to endangered songbirds like the Kirkland's warbler and the black-capped vireo, up to two hundred species of bird moms have something to fear.

Acknowledgments

Thanks to Kate, Hannah E., Cassy, Claire, Bunny, Max, Mom, Dad, pop music, and long walks.

WHERE IN THE WORLD IS ...

*Symbiosis?**

*Locations not exact

1. Cleaner Shrimp and Really Clean Fish

2. Burrowing Tarantula and Dotted Humming Frog

3. Leafcutter Ants and Lepiotaceae Fungus

4. Banded Mongoose and Common Warthog

5. Coyote and American Badger

6. Blue Wildebeest and Zebra

7. Clownfish and Sea Anemones

8. Moray Eels and Roving Coralgroupers

9. Bottlenose Dolphins and False Killer Whales

10. Yucca Moth and Yucca Plant

11. Hawaiian Bobtail Squid And *Aliivibrio Fischeri* (Bioluminescent Bacteria)

12. Clark's Nutcracker and Whitebark Pine Trees

13. Three-Toed Sloth, Sloth Moth, and Algae

14. Golden Jellyfish and Zooxanthellae Algae

15. Pistol Shrimp and Goby Fish

16. Mimic Octopus and Everyone Else

17. Yellow-Rumped Cacique and *Polybia Rejecta* Wasps

18. Oceanic Whitetip Shark and Pilot Fish

19. *Pitcher Plant and Red Crab Spider*

20. Bluestreak Cleaner Wrasse and False Cleaner Fish

21. *Lybia* Crab and Sea Anemone

22. Rhinoceros and Oxpecker

23. The Parasitic Mating of Anglerfish

24. Ants and Aphids

25. Baleen Whale and Barnacles

26. Monarch and Viceroy Butterflies

27. Pearlfish and Sea Cucumber

28. Rough-Skinned Newt and Garter Snake

29. Hummingbirds, Flower Mites, and Hamelia Flowers

30. Sea Otters, Sea Urchins, and Kelp

31. *Ophiocordyceps* Fungus and Carpenter Ants

32. Jewel Wasp and American Cockroach

33. Vampire Bats and Livestock

34. Tongue-Eating Isopod and the Least-Lucky Fish of All Time

35. Brown-Headed Cowbird and All Future Bird Moms

About the Author

IRIS GOTTLIEB is an illustrator and layman scientist. She grew up collecting dead and living things and has continued to do so, documenting and researching them along the way. She has collected 3,614 shark teeth. When not exploring, Iris works with museums, publications, and individuals as a freelance illustrator, animator, and graphic recorder. She is the on-hand illustrator for the San Francisco Exploratorium's Tinkering Studio as well as an illustrator at the Oakland Museum of California. If she were an animal, she would be a deer wandering in the woods of North Carolina. She really loves her dog. This is her first book.